LEGENDAF

o

MIDDLETOWN

CONNECTICUT

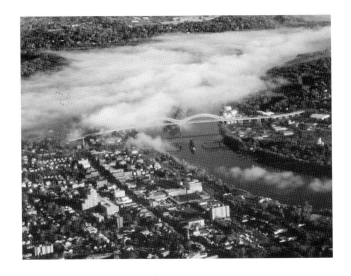

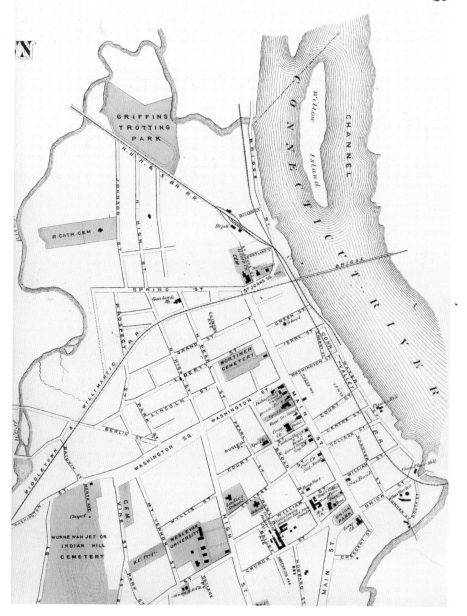

Map of Downtown Middletown

This 1874 map shows the two-year-old Air Line railroad bridge, which provided a connection with Portland on the east side of the Connecticut River. A ferry north of this bridge allowed pedestrians and animals to cross. (Courtesy the Middlesex County Historical Society.)

Page 1: Downtown and the River

This 2008 photograph clearly shows the Charles J. Arrigoni Bridge, which was completed in 1938. Today, it is the means by which pedestrians, bicyclists, and drivers move directly between Middletown and Portland. (Courtesy Robert Polselli.)

CONTENTS

ACKNOWLEDGMENTS

In recognizing the people who helped with this book, there is one name that holds an unchallenged first place—attorney Deborah D. Shapiro, the executive director of the Middlesex County Historical Society. We are grateful for her advice, assistance, and friendship. In the eight months we worked on this book, we spent dozens of days at the society's Mansfield House headquarters and saw firsthand how much the historical society benefits from her leadership, hard work, creativity, and unequalled knowledge of the city and its people. In 2011, the Middlesex County Chamber of Commerce presented attorney Shapiro with its Distinguished Citizen Award. Never was an award more appropriate or more deserved.

We are also grateful for the assistance of Denise Russo of the Russell Library; Leith Johnson, Wesleyan University Archivist; and Suzy Taraba, Wesleyan's director of special collections and archives. These professionals went out of their way to locate and provide materials that substantially enhanced our book. Thank you!

Thanks also for the contributions of John E. O'Brien. His extensive knowledge of the history of Middletown athletics allowed us to provide important information that we would have overlooked.

Some of the people who have contributed valuable information and/or photographs are: Joan Adorno, Jerry Augustine, Janet McCutcheon Batt, Andrew and Anong Becker, John Biddiscombe, Scott Bishel, Susan Bysiewicz, William Corvo, Vic Damon, Margaret McCutcheon Faber, Alessandro J. Fernandez, Santo Fragilio, Robert Fralick, David Garry, Kathleen Hickey Kane, Jerome Levin, Marc Levin, Nihla Lapidus, Louis and Eleanor LaPila, David Larson, Amanda Lucier, Mark Masselli, Lois McCutcheon, Ronald W. McCutcheon, Lawrence McHugh, Willard McRae, Wilfredo Nieves, Richard G. Notarangelo, Mary and William Papaleo Jr., John Pastor, Janet Peoples, Phil Pessoni, Ted Raczka, Christina Rickenback, Steve Scionti, Russell Settipane, John B. Sterry Jr., Richard Wrubel, and Ted and Mary Xenelis.

We also want to thank Erin Vosgien, senior acquisitions editor at Arcadia Publishing, who was always available to answer questions and give expert advice. Thanks also to Jim Kempert for his work in finalizing this book.

Thanks also are due to former Middletown mayors Michael Cubeta, Thomas Serra, and Maria Madsen Holzberg, as well as the current mayor's office. We are also grateful for the assistance of Philip Cacciola, who in his leadership positions at the American Legion and the Middletown Sports Hall of Fame gave us access to important information and photographs.

Lastly, we would like to thank photographers Robert Polselli and John Giammatteo for donating their time and expertise—Robert for the aerial photograph on page one and John for reproducing several historical paintings. Unless otherwise noted, all images in this book are from the collections of the Middlesex County Historical Society.

INTRODUCTION

Composing *Legendary Locals of Middletown* gave us an opportunity to examine the lives of many interesting and influential people. We saw what motivated them, read or heard their extraordinary stories, marveled at the passion of their quests, and appreciated the humanity and determination that led them to success. It provides a platform that stretches across the years—from the past, through the present, and, because of their actions, into the future. Legendary Locals titles are not limited to a historical time period, so we were able to include current events and a diverse mixture of people. The book evolved into six chapters, covering people who were born in Middletown, relocated here for a period of time, or transplanted themselves here, staying for the rest of their lives. It was a daunting task to dip into the broad spectrum of life and organize people and events into categories—trying to portray each individual's spirit while condensing their contributions into a brief synopsis.

In 1650, a small group of Hartford men and women traveled south on the Connecticut River in a quest for a new home. They stopped at the only major bend in the river, the place now called Middletown. There, they built homes, planted crops, and tried to establish relations with the local Native Americans. Although the area remained strong agriculturally, it was the river and the trade it brought with it that was the key to Middletown's growth and prosperity through the 18th and 19th centuries. Business leaders built the town into one of America's foremost international trading ports. Even though it was about 25 miles from the mouth of the Connecticut River, Middletown was designated a US customs port in 1795.

Although some individuals, such as Samuel Russell, continued to grow incredibly wealthy through the seagoing trade, the Industrial Revolution brought many factories to Middletown. This, in turn, led to the introduction of the railroad and the Middletown-Portland railroad bridge. In the 20th century, retail establishments sprouted up as Middletown became more of a residential community and served as the home of two institutions of higher education. Many of Middletown's important business people are covered in chapter one.

The second chapter, on athletics, highlights not only the stars of high school sports teams, but also includes athletes who have excelled in other areas, like running, bicycling, and prizefighting. Middletown has more than its share of these competitors, as can be seen by the long list of fine athletes who have been inducted into the Middletown Sports Hall of Fame.

The third chapter, on the arts, recognizes musicians, writers, artists, and actors. Some names are immediately recognizable, while others might be best known from their work. Many of Henry Clay Work's once-popular Civil War songs are little known today, but his classic "Grandfather's Clock" is still a hit with schoolchildren. Not many of the 1930s movie musicals for which Allie Wrubel wrote are available on Netflix, but virtually every American recognizes "Zip-a-Dee Doo-Dah," which he composed for Disney Studios. Albert McCutcheon, a local artist, was commissioned by the Works Progress Administration to create murals in area schools. Fine arts programs at Wesleyan University have honed students' creativity. Many well-known artists, such as screenwriter David Webb Peoples, are among its alumni.

The chapter on educators and government leaders includes a number of outstanding teachers and civic leaders who have been honored by having Middletown landmarks named after them. Many readers will wonder how Spencer, Wesley, Bielefield, Lawrence, and Keigwin schools received their names. Others ponder the origin of Sbona Drive, Nejako Drive, and Santangelo Circle. The stories of the people behind these names lie within these pages.

The military chapter is a salute to Middletown men and women who have fought and, in all too many cases, died for their country. The chapter starts with the war that gave the nation its independence

and progresses to the recent wars in the Middle East. In the Civil War, over 950 Middletown men served in the Union forces. As a salute to America's veterans, a few of these gallant people are recognized in these pages.

The last chapter, which focuses on unforgettable people, is a compilation of Middletown individuals who did not fit into previous chapters—the Native Americans who first lived on the land, the 17th-century English settlers, pioneers in medicine, community activists, health-care innovators, hospital volunteers, and other legendary locals.

Scottish writer Thomas Carlyle stated, "The history of the world is but the biography of great men." We might add that the history of Middletown is but the biography of men and women, both great and small.

CHAPTER ONE

Business People

This chapter illustrates how business has changed over the centuries. In Middletown's infancy, the first settlers were farmers making a living off the rich soils of the Connecticut River valley. As time went by, the river attracted traders, shipbuilders, and others connected with marine commerce. By the late 1700s, this resulted in Middletown becoming one of the most prosperous cities in Connecticut.

As the Industrial Revolution of the 1800s brought in factories and mills, thousands of workers found new jobs. Middletown companies produced water pumps, marine hardware, typewriters, firearms, and swords. The city became the world leader in the production of elastic webbing. Employers included the J.R. Watkinson woolen mill, the Baldwin Tool Co., W.H. Chapman Co., I.E. Palmer Co., and the Wilcox & Co. Lock factory. Soon, electric trolley cars replaced horses, and railroads and bridges became more important than sailing ships and ferries. The Middletown Electric Light Co. made it easy to transition from the waterpower of the Pameacha and Coginchaug Rivers to electric power. During the late 19th and early 20th centuries, Middletown attracted ambitious and hard-working immigrants who established Irish, Italian, Jewish, Polish, German, and Swedish communities.

In the 21st century, Middletown has been enriched by new immigrants from Puerto Rico, Mexico, Southeast Asia, India, and many other places. The diversity of successful ethnic restaurants reflects this trend. Many old names survive today. The Bishel family still operates the Smith & Bishel hardware store on Main Street, the Xenelis family still is in the business of selling the freshest fruit, John Sterry Jr. at Fox-Becker Granite Co continues to create and sell high-quality granite memorials, and the Vecchitto family still makes the best Italian ice in Connecticut.

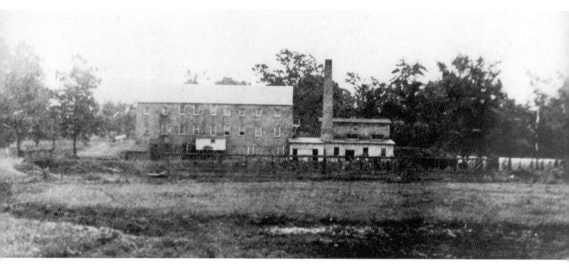

Simeon North

Arms manufacturer Simeon North pioneered the use of interchangeable parts and developed what was possibly the first milling machine. This photograph shows his factory on the West River in the Staddle Hill section of Middletown. It was said to be the largest factory in the United States at the time it was built in 1812. For 53 years, North provided pistols, rifles, and other armaments to the War Department, the predecessor of today's Department of Defense. North died in 1852 at age 87.

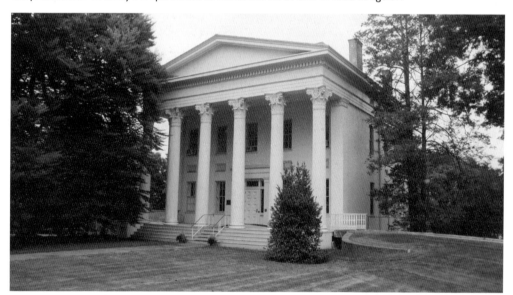

Samuel Russell: Wealthy Trader

Born in Middletown, Samuel Russell (1789–1862) was one of the city's wealthiest businessmen and traders. In 1824, he founded Russell & Company, which by 1842 was the largest American trading house in China. It traded mostly in silks, teas, porcelain, and opium. In 1836, Russell resigned from company management. Upon returning to Middletown from China, Russell founded the Russell Manufacturing Company with his friend Samuel Dickinson Hubbard. The company manufactured suspenders and supplied cartridge belts, parachute harnesses, and other items to the military in both world wars. He passed away in 1862. Pictured here is the Greek Revival mansion Russell had built for his wife in 1828.

Albert R. Crittenden
In 1869, 26-year-old Civil War veteran Albert R. Crittenden purchased a one-tenth interest in a 22-year-old metal grommet company owned by William Wilcox. After the deal, it was renamed Wilcox, Crittenden & Company. As sailing ships were being replaced by steam vessels, the company diversified its product lines, producing awnings and other products. By the 1880s, it was the largest producer of marine hardware in the United States. Crittenden passed away in 1921 at age 77. Pictured here is the Wilcox, Crittenden & Company facility on South Main Street.

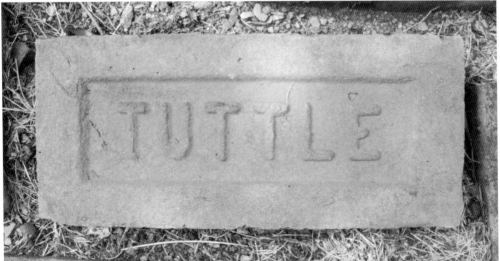

George L. Tuttle: Brick Maker
The founder of Middletown's Tuttle Brick Co., George Tuttle ran the company from 1842 until his death 48 years later. His first brickyard was located near the Newfield railroad station, about two miles north of downtown Middletown. After Tuttle's passing in 1890, his sons George Jr., Lewis, Wallace, and Willis formed Tuttle Bros. By 1909, the company had three plants with a combined output of 200,000 bricks per day. The Connecticut State Library and Supreme Court building in Hartford is one of many structures made of Tuttle bricks.

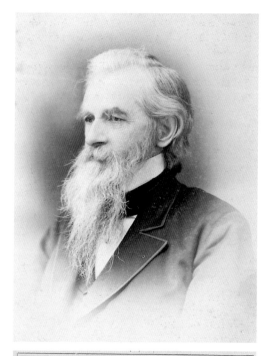

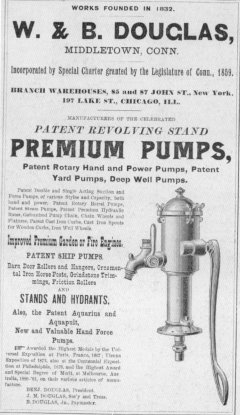

WORKS FOUNDED IN 1832.

W. & B. DOUGLAS,

MIDDLETOWN, CONN.

Incorporated by Special Charter granted by the Legislature of Conn., 1859.

**BRANCH WAREHOUSES, 85 and 87 JOHN ST., New York.
197 LAKE ST., CHICAGO, ILL.**

MANUFACTURERS OF THE CELEBRATED

PATENT REVOLVING STAND

PREMIUM PUMPS,

**Patent Rotary Hand and Power Pumps, Patent
Yard Pumps, Deep Well Pumps.**

Patent Double and Single Acting Suction and
Force Pumps, of various Styles and Capacity, both
hand and power. Patent Rotary Barrel Pumps,
Patent Steam Pumps, Patent Premium Hydraulic
Rams, Galvanized Pump Chain, Chain Wheels and
Fixtures, Patent Cast Iron Curbs, Cast Iron Spouts
for Wooden Curbs, Iron Well Wheels.

Improved Premium Garden or Fire Engines.

PATENT SHIP PUMPS.

Barn Door Rollers and Hangers, Ornamen-
tal Iron Horse Posts, Grindstone Trim-
mings, Friction Rollers

AND

STANDS AND HYDRANTS.

Also, the Patent Aquarius and
Aquapult,
New and Valuable Hand Force
Pumps.

Awarded the Highest Medals by the Uni-
versal Exposition at Paris, France, 1867; Vienna
Exposition of 1873, also at the Centennial Exposi-
tion at Philadelphia, 1876, and the Highest Award
and Special Degree of Merit, at Melbourne, Aus-
tralia, 1880-'81, on their various articles of manu-
facture.

BENJ. DOUGLAS, President.
J. M. DOUGLAS, Sec'y and Treas.
B. DOUGLAS, Jr., Paymaster.

Benjamin Douglas: Abolitionist and Businessman

In 1839, twenty-three-year-old Benjamin Douglas went to work at his brother William's foundry and machine shop in Middletown. They renamed it W. & B. Douglas, and a few years later, invented a new type of revolving stand pump for use in factories and on farms. It was an immediate success and made the Douglases wealthy. William died in 1858, but Benjamin remained the company's president until his passing in 1894. At its height, W. & B. Douglas manufactured over 1,200 styles and sizes of pumps in factory buildings located near today's Sbona towers. Active in politics, Benjamin Douglas was a founder of the Connecticut Republican Party, and in 1861 was elected lieutenant governor of Connecticut. Today, he is perhaps best known for his ardent antislavery work. A key member of the Middletown Anti-Slavery Society, Douglas is believed to have helped slaves reach freedom via the Underground Railroad. As mayor of Middletown (1850–1856), he publicly refused to obey the Fugitive Slave Act of 1850.

BARTON'S bonbonniere

Rosh Hashanah

Holiday Assortments

Plastic Shofar

Filled With Fruit Pops

99¢

CHOCOLATES PETITS FOURS

Luscious layers of real French pastry with butter-cream fillings in 5 out-of-this-world flavors. All chocolate covered.

| 40 PIECES | $2.95 |
| 24 PIECES | $1.79 |

Continental Cookies	$1.98
Pecan Honey Cake	1.10
Taiglach Loaf	1.59
Rosh Hashanah Gift Tin	2.49
Parve Chocolates	$1.93

New Year's Asst.

Milk And Bittersweet

$1.93

James Bunce: Department Store Founder

In 1861, 32-year-old James Bunce established a 20-by-80-foot dry-goods store in Middletown. In five years, it came to occupy 65,000 square feet. At his death in 1908, Bunce's department store had grown to one acre of shopping space, with separate elevators for freight and customers and a ladies' resting and waiting room with toilets. It was the tallest building on Main Street, and residents considered it to be the closest thing to a New York City department store that could be found in central Connecticut. Today, the Main Street Market occupies the Bunce building.

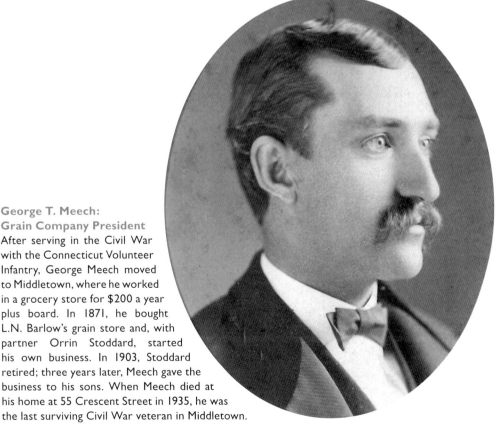

George T. Meech: Grain Company President

After serving in the Civil War with the Connecticut Volunteer Infantry, George Meech moved to Middletown, where he worked in a grocery store for $200 a year plus board. In 1871, he bought L.N. Barlow's grain store and, with partner Orrin Stoddard, started his own business. In 1903, Stoddard retired; three years later, Meech gave the business to his sons. When Meech died at his home at 55 Crescent Street in 1935, he was the last surviving Civil War veteran in Middletown.

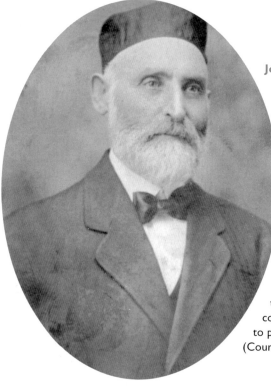

Joseph and Sarah Shapiro

In 1896, Joseph Shapiro (1857–1927) left his native Poland for America. He was forced to close his tavern when the czar decreed that only gentiles would be permitted to hold liquor licenses. His wife, Sarah (1865–1952), joined him in Middletown four years later. When their children entered with her through New York's Ellis Island, they were given bananas, but since they did not know what the fruit was, they threw them into New York Harbor. The family worked hard to succeed and established and grew one of the most popular retail stores in central Connecticut, serving customers for more than 80 years. Joseph's son Harry, who took over the business, was very active in the community and was known for selling clothes to people on credit during the Great Depression. (Courtesy the Shapiro family.)

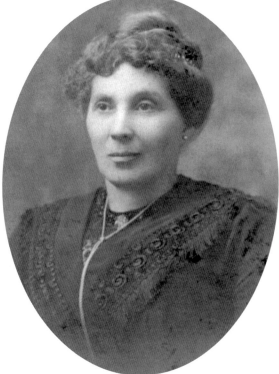

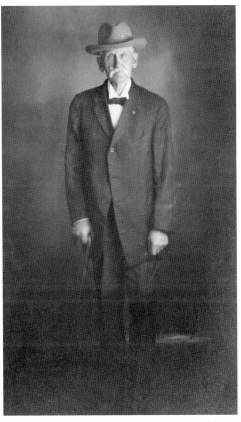

Charles Abner Pelton: Drugstore Owner
In 1855, Charles Pelton (1839–1930) was a clerk
at Southmayd Company, which sold products
like medicinal oils from the Caribbean Islands
and Europe. The business was later owned by
G. Boardman and the Hubbard family. After
returning from the Civil War, Pelton partnered
with C.P. Collins and purchased the business.
When Pelton took over as the sole owner in
1871, he renamed it Pelton's Drug Store. Pelton
died in 1930. At that time, he was Middletown's
second-to-last living veteran of the Civil War. The
photographs here show an older Pelton and his
Civil War pistol, which was made by Middletown's
Savage Revolving Firearms Company.

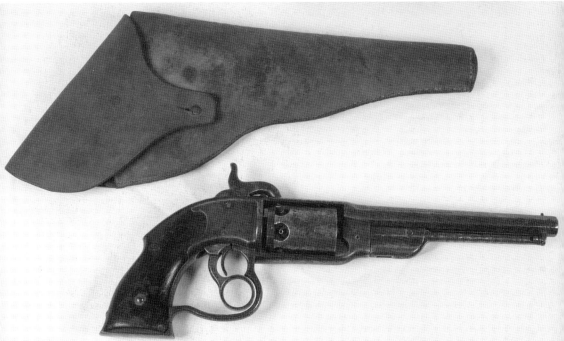

Herrmann's Delicatessen

For 45 years, German-born Carl T. Herrmann owned and operated Herrmann's Delicatessen on Main Street. Opening in 1914, Herrmann's provided Middletown's German population with foods that they remembered from their youth. The more adventurous clientele tried some of the unusual items that he stocked, like rattlesnake meat and chocolate-covered ants. One unpleasant event occurred in 1918. At the time, American soldiers were fighting against Germany in World War I. Back in Middletown, troublemakers were stirring up hatred toward German Americans. One night, a mob of 100 men showed up at Carl Herrmann's home, broke down his door, and condemned him as anti-American. After they made him kiss an American flag, they demanded he give a speech. At that moment, his son, Carl F. Herrmann, intervened and spoke up for his father's patriotism. The mob dispersed only when the police were called in. That same night, the mob broke into the German community's Evangelical Lutheran Church on High Street. In the trial of four men accused of the attack on the Herrmanns, the prosecutor, Bertrand Spencer (later the namesake of Spencer School), called the incident an outrage and a blot on the name of the city. Eventually, three of the men were convicted. In 1931, the deli was purchased by Carl Jr. from his father and remained in business until 1977. Thereafter, Herrmann and his wife, Elizabeth, devoted their time to their other interest, a horse-training center near Crystal Lake. Shown here is the interior of Herrmann's liquor store, which adjoined the delicatessen. The Herrmanns opened it soon after Prohibition was repealed in 1933.

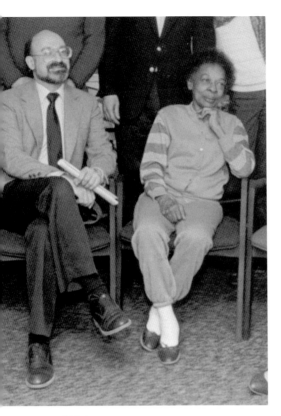

Jerry Weitzman:
Pharmacist and Community Leader

Jerry Weitzman's father, Benjamin, began working as a clerk at Charles Pelton's drugstore in 1917 and purchased it in 1928. When Benjamin became ill in the late 1950s, Jerry decided to study to be a pharmacist so he could help in the family business. Graduating in 1960 from the University of Connecticut School of Pharmacy, he ended up owning, modernizing, and expanding the business. By 1977, the original Pelton's on Main Street had a post office, sold home health-care products, and eventually expanded to other Connecticut locations. Along with Mark Masselli and Reba Moses, Weitzman cofounded the Community Health Center. Moses and Weitzman are pictured above. In 1999, Weitzman and his wife died in a car crash. The only store remaining today is Pelton's Home Health Care in Wethersfield. The original Middletown store is pictured at right.

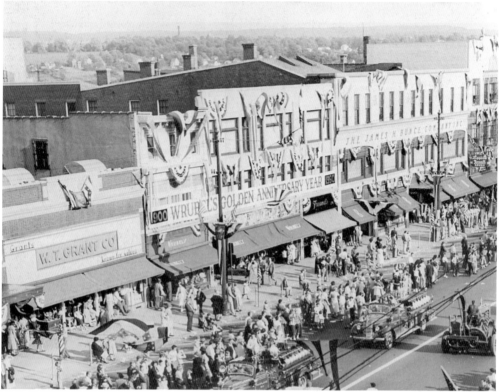

The Wrubel Family

Isaac Wrubel settled in Middletown just before the beginning of the 20th century. As a ladies' tailor and a dry-goods merchant, Isaac and his wife opened a clothing store on Main Street in 1900 making women's cloaks. The Wrubel family expanded (sons Arthur, Bernard, Robert, William, and Elias "Allie" and daughters Rachel and Dorothy), and the business grew. Arthur Wrubel, Isaac's oldest son, and Mildred, Arthur's wife, often went on buying trips to Europe to purchase fashionable women's clothing. After 64 years in business, Wrubel's was sold in 1965 to Newman-Benton Stores, a subsidiary of Lane Bryant Inc. The building was sold in 1972. The last owner-operator of a Wrubel's family store was Richard Wrubel, who for almost 20 years owned Richard Wrubel's Inc. in Wethersfield. He now has a business-consulting firm in Middletown. The Wrubel's store appears in the center of the above photograph, taken in 1950. Richard Wrubel is pictured at right.

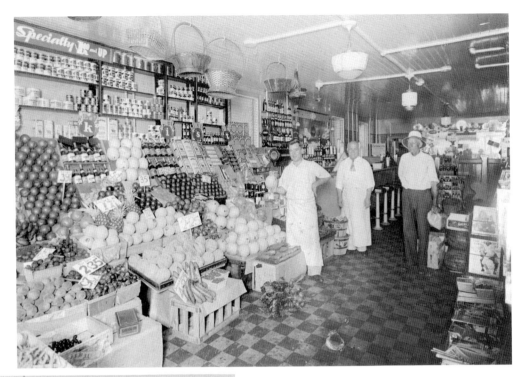

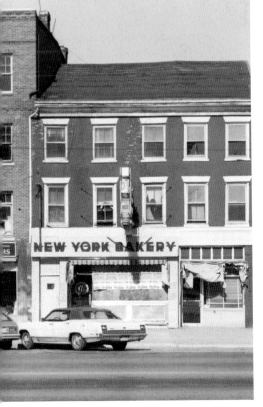

The Xenelis Family

In the mid-1920s, Costas "Gus" Xenelis and his father, Nicholas, from Eressos on the Greek island of Lesvos, opened a fruit and confectionery store at 191 Main Street. In 1931, Nicholas died. Gus and his wife, Jessie, ran the Middlesex Fruitery for over 50 years. Today, the business is owned and operated by Nicholas's grandson, Ted Xenelis, and Ted's wife, Mary. They abide by the same full-service policy implemented by Gus: only a family member or a clerk may handle the produce. (Courtesy Ted and Mary Xenelis.)

Jacob Zibulsky: New York Bakery

As a young boy, Jacob Zibulsky worked in his father's bakery in Poland. When he came to America, he started a bakery on Coney Island; in the 1940s he came to Middletown, where he opened the New York Bakery on the south end of Main Street. Many Middletown residents recall being enticed by the aromas of rye, pumpernickel, and challah breads. Many loyal customers stopped by after Sunday church services to get a dozen hard rolls and donuts for the kids. Zibulsky was active in Congregation Adath Israel and in community groups like the Elks and YMCA.

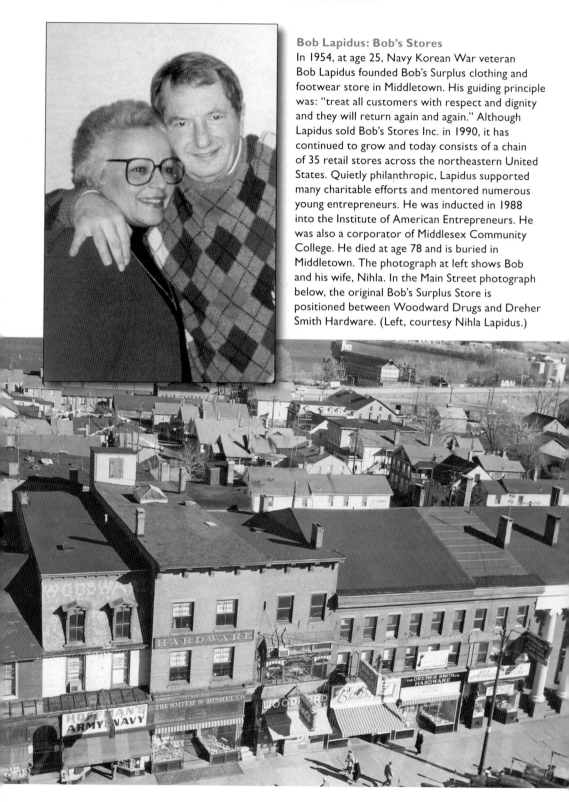

Bob Lapidus: Bob's Stores

In 1954, at age 25, Navy Korean War veteran Bob Lapidus founded Bob's Surplus clothing and footwear store in Middletown. His guiding principle was: "treat all customers with respect and dignity and they will return again and again." Although Lapidus sold Bob's Stores Inc. in 1990, it has continued to grow and today consists of a chain of 35 retail stores across the northeastern United States. Quietly philanthropic, Lapidus supported many charitable efforts and mentored numerous young entrepreneurs. He was inducted in 1988 into the Institute of American Entrepreneurs. He was also a corporator of Middlesex Community College. He died at age 78 and is buried in Middletown. The photograph at left shows Bob and his wife, Nihla. In the Main Street photograph below, the original Bob's Surplus Store is positioned between Woodward Drugs and Dreher Smith Hardware. (Left, courtesy Nihla Lapidus.)

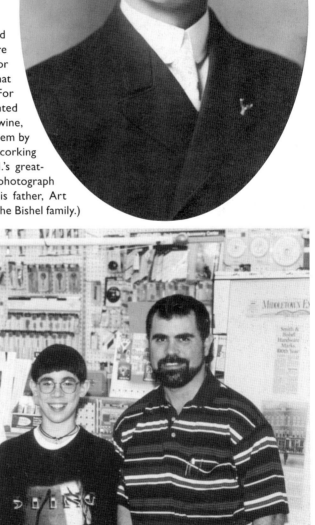

The Bishel Family

In 1898, A.H. Bishel founded Smith and Bishel, Middletown's oldest hardware store. The Bishels have a reputation for stocking hard-to-find, quality products that cannot be found in box-store chains. For example, when Italian immigrants wanted to continue their tradition of making wine, Smith and Bishel Hardware assisted them by selling corks to pressers and fittings to corking machines. The current owner is A.H.'s great-great-grandson, Scott Bishel. In the photograph below, he is standing at right with his father, Art (left), and his son, Patrick. (Courtesy the Bishel family.)

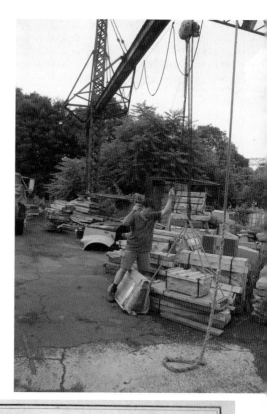

**John B. Sterry Jr. and
Fox-Becker Granite Company**
After more than 100 years, Fox-Becker Granite Co.
continues to sell high-quality memorial granite signs.
Founded in 1898, the company moved in 1900 to the
north end of Main Street on Rapallo Avenue, where
it connected to the Union Depot by a sidetrack.
The company has sculpted cemetery memorials
for historian William Manchester and Connecticut
governors Chester Bowles and Raymond E. Baldwin.
In this photograph, company president John B.
Sterry Jr. operates Fox-Becker's original 33-foot-
high derrick.

Sal Didato: Oil Service
Salvatore J. "Sal" Didato Sr. and his future wife, Maria Pitruzello, met when he was selling fresh ricotta
cheese from his family's farm. In the early 1950s, they founded S.J. Didato's Oil Service Co. and Didato's
Service Station. Sal was active in community affairs, treasurer of the Republican Town Committee for
14 years, and a trustee of St. Sebastian Church for 45 years. He passed away in 2005.

Margarito Rodriguez: Puerto Vallarta, Great Mexican Food
Owner of the Puerto Vallarta Mexican restaurant in Middletown, Margarito Rodriguez and most of his nine brothers and sisters own and operate 11 Mexican restaurants. Puerto Vallarta caters primarily to families. When Rodriguez serves hot dishes himself, he will caution patrons, "It's very hot, muy caliente." He says that it is common for children, when seeing him away from the restaurant, to say to their parents, "There's Mister Muy Caliente!"

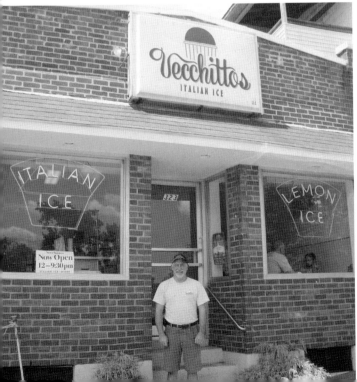

The Vecchitto Family: 80 Years of Italian Ice
Since 1927, when Gaettano Vecchitto opened an Italian ice store on Middletown's DeKoven Drive, the Vecchitto family has provided customers with a dessert that is second to none. Vecchitto's Italian Ice has opened every summer for more than 80 years, with lemon and chocolate ices being among its most popular flavors. After Gaettano retired, the business was operated by three of Gaettano's ten children. Pictured here is Guy Vecchitto, one of today's co-owners.

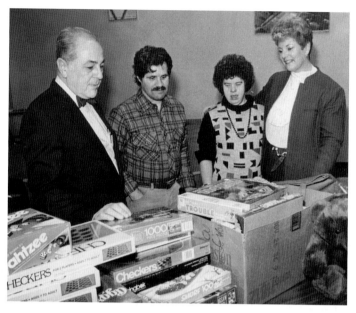

Vincent Amato: Toy and Hobby

A native of Middletown, Vincent "Vinnie" Amato (1925–2012) opened a hobby store in 1940 inside his father's plumbing and heating business. It grew into Amato's Toy and Hobby, which has stores in Middletown and New Britain and carries hard-to-find toys and hobby items, like trains and model airplanes. As a boy growing up in the 1930s, Amato admired pilots and built airplane models. This interest continued as he entered Army Air Corps officer training, becoming a lieutenant navigator for B-29s. Following the war, he married, raised a family, and expanded his business, moving to several Main Street locations and opening up new stores in surrounding towns. Crucial to Vincent Amato's success was his active involvement in his stores, his entrepreneurial spirit, and his concern for the local community. He encouraged other local business people and served as president of the National Hobby Industry Association. As a civic leader, he generously gave his time to many Middlesex county organizations and was one of the founding members of the Jaycees. Amato is pictured at left above.

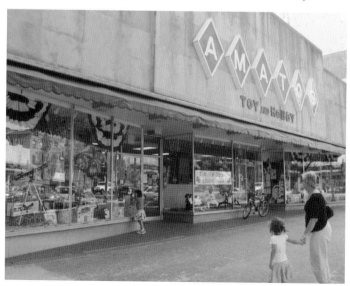

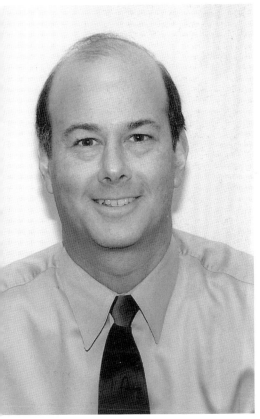

Marc Levin and Malloves Jewelers
In 1938, the Mallove family sold its 10-year-old Middletown jewelry store to Max and Joseph Levin. Max's son, Buzzy, who earlier had sacrificed a tryout with the Brooklyn Dodgers to help run the store, bought it in 1957. In 1992, Buzzy's son, Marc, an accomplished athlete like his father, became the store's president. A member of the Middletown Sports Hall of Fame, Marc (above) was an outstanding baseball player at Xavier High School, the University of Tampa, and, for six years, the Greater Hartford Twilight League. One of the reasons for Malloves' success has been Marc's actions to give back to the community through such events as sports sponsorships, interfaith golf tournaments, and breast cancer and hospice fundraisers.

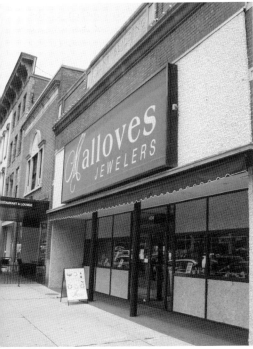

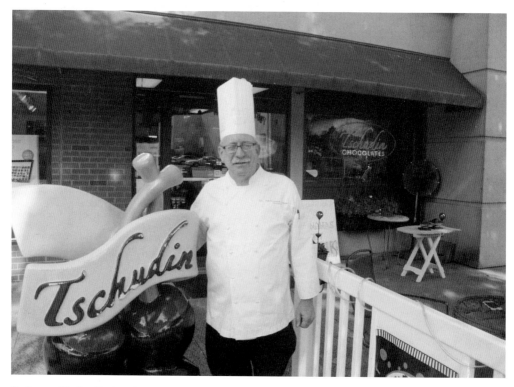

Roberto Tschudin Lucheme: Everything Chocolate

The Tschudin Chocolates & Confections store, at the corner of Court and Main Street, offers handmade chocolates as well as made-to-order tarts and exotic cakes. Its owner, Roberto Tschudin Lucheme, possesses as many talents as the store has chocolate selections. An attorney by profession, he has worked as a trainer of firefighters, a television shopping network host, and a high-wire walker.

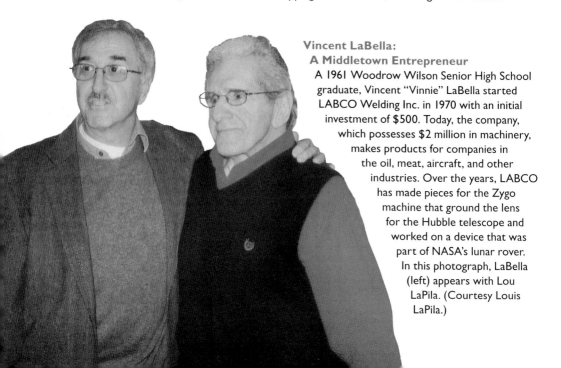

Vincent LaBella:
A Middletown Entrepreneur
A 1961 Woodrow Wilson Senior High School graduate, Vincent "Vinnie" LaBella started LABCO Welding Inc. in 1970 with an initial investment of $500. Today, the company, which possesses $2 million in machinery, makes products for companies in the oil, meat, aircraft, and other industries. Over the years, LABCO has made pieces for the Zygo machine that ground the lens for the Hubble telescope and worked on a device that was part of NASA's lunar rover. In this photograph, LaBella (left) appears with Lou LaPila. (Courtesy Louis LaPila.)

CHAPTER TWO

Athletes

Middletown schools have provided some of the finest athletes in the state. Many are showcased in this chapter. Some of the star athletes from Middletown High School not mentioned in this chapter are Theodore "Bear" Bartolotta, Lawrence Battistini, John Denunzio, Dorothy Franklin DiMauro, Sebastian "Prof" Gallitto, Stacia "Skeets" Gayeski, Paul LaBella, Louis J. Milardo, Mike Pitruzzello, Wilber J. Pope, Phil Stekl, Nancy Cacciola Tarantino, Ted Tine, Alexander Tucci, and Steve Witkowski.

Outstanding Woodrow Wilson High School sports figures include Stan Kosloski (who later competed in wheelchair basketball for the Connecticut Spokebenders), Harold C. Levy, Joseph Jake Salafia, John Skubel, Rosemary M. Stratton, James M. Sullivan, John Tucci, and Joseph Tripp. Xavier High notables include Jack Fleming, athletic director Arthur "Artie" Kohs, Mike Kohs, and head football coach Sean Marinan, winner of three straight Class LL championships. Mercy High School's standouts include Paula Kohs Drake and Teresa Opalacz, and Vinal can boast of Robert Bruzik and Carl Lombardo.

These female athletes deserve recognition: professional softball star Lucille Gecewicz, semiprofessional basketball star Rose Medaloga Bafuma, and Dorothy Czajka Valenti, who was ranked in the top 10 among Connecticut women bowlers 17 times.

Wesleyan University sports figures include Ambrose Burfoot, the 1968 Boston Marathon winner and now editor-in-chief of *Runner's World*; Bill Rodgers, four-time winner of the Boston and New York City Marathons; and Wesleyan's longtime football coach and athletic director, Donald M. Russell.

Also deserving acknowledgment are legendary sports announcer Arnold Dean, who hosted the first 19 Middletown Sports Hall of Fame induction ceremonies; Albert Hamrah, the originator of the Middletown Sports Night Dinner that raised hundreds of thousands of dollars for charities; James Bransfield, best known as "The Voice of Palmer Field;" horseshoe champ Mickey Vecchitto; and Joseph Marino, an early pioneer of sports for people with hearing impairments.

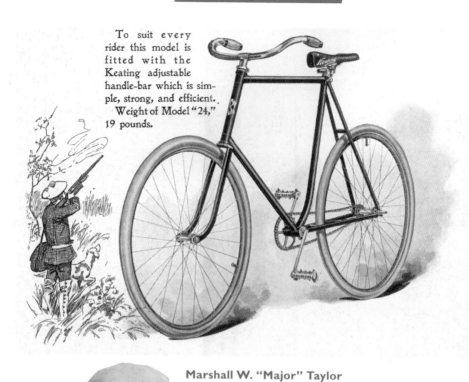

To suit every rider this model is fitted with the Keating adjustable handle-bar which is simple, strong, and efficient.
Weight of Model "24," 19 pounds.

Marshall W. "Major" Taylor

Major Taylor was a late 19th century bicyclist who became the second African American to win a world sports championship. (The first was bantamweight prizefighter George Dixon.) In 1899, Taylor won the world one-mile track cycling championship in Montreal, Canada, after training in Middletown. At the time, Middletown was an important center of bicycle racing and manufacturing. This is a drawing from the Keating Bicycle Company's 1896 catalog. Keating's factory was in the large building in the north end of Middletown that later became a Remington Rand typewriter production facility.

C. Everett Bacon:
College Football Hall of Famer

A graduate of Middletown High School and an eight-letter athlete in football, baseball, golf, and tennis at Wesleyan University, Bacon was considered a pioneer in the use of the forward pass. In 1966, he was inducted into the College Football Hall of Fame. He passed away in 1989 at age 98. Wesleyan University has named a field house after Bacon and annually presents the C. Everett Bacon Award to its most valuable football player. (Courtesy Wesleyan University.)

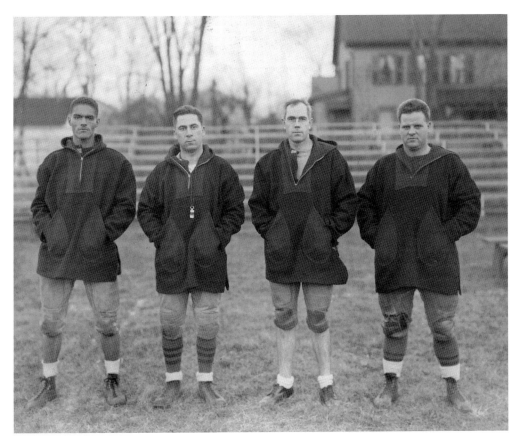

Arthur J. Warmsley: Long Jump Record Holder

A top Middletown High School football and track athlete, Arthur Warmsley held Middletown High School's long jump record for many years. Warmsley was a US Army veteran of World War II, cofounder of the Connecticut Philatelic Society, the author of two books about Connecticut postal history, and the longtime head sports photographer for the *Hartford Courant* newspaper. Warmsley died in 1998 at age 84. Pictured here is the 1937 Middletown High coaching staff. They are, from left to right, Arthur Warmsley, L. Battistini, D. Barrows, and B. DeMonte. (Courtesy Middletown Sports Hall of Fame.)

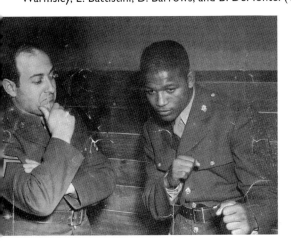

Joseph Lombardo: "The Mayor of the North End"

For more than 60 years, Joseph Lombardo's barbershop was a fixture on Middletown's Main Street. His interest in politics was such that he was dubbed "The Mayor of the North End." His talents went beyond his occupation, as he was a semiprofessional football player, and he and his friend, Noc Marino, formed a comedy team, Noc and Joe. In 2000, Joe Lombardo died at age 85. This photograph shows him with world welterweight champion "Sugar Ray" Robinson when both were stationed at Fort Dix in 1942. (Courtesy Middletown Sports Hall of Fame.)

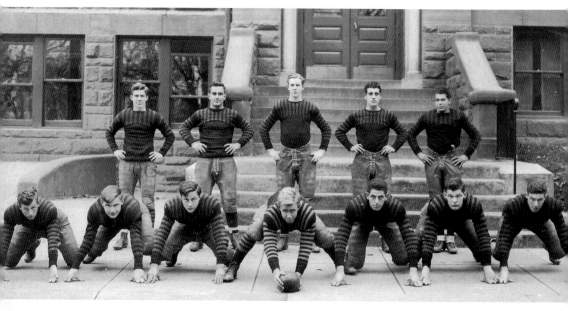

Bill Pomfret: Middletown's Mr. Baseball

Pomfret, a second-generation Irish-American, was captain of Middletown High School's baseball and basketball teams, and played semiprofessional baseball and basketball. A World War II Marine veteran, he was active in the American Legion, bringing state baseball championships to Middletown. The baseball stadium at Palmer Field is named for him. Pomfret passed away in 2010 at age 93. In this photograph of the 1934 Middletown High football team, Pomfret is at center in the second row. (Courtesy Middletown Sports Hall of Fame.)

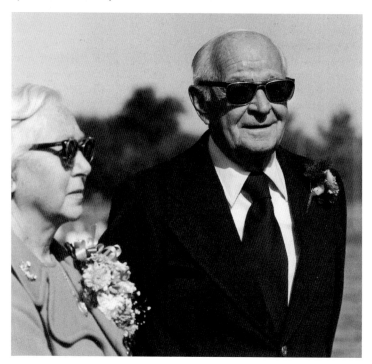

Waino Fillback: Coach Extraordinaire

For 25 years, beginning in 1943, Waino Fillback was a teacher, coach (football, basketball, and track), and athletic director at Middletown High School. He later coached football at St. Thomas More School and football and track at Wesleyan University. This photograph shows Fillback with his wife, Loretta, at the Middletown High School field on Wilderman Way, which was named for him. Fillback died in 2000 at age 94. (Courtesy Middletown Sports Hall of Fame.)

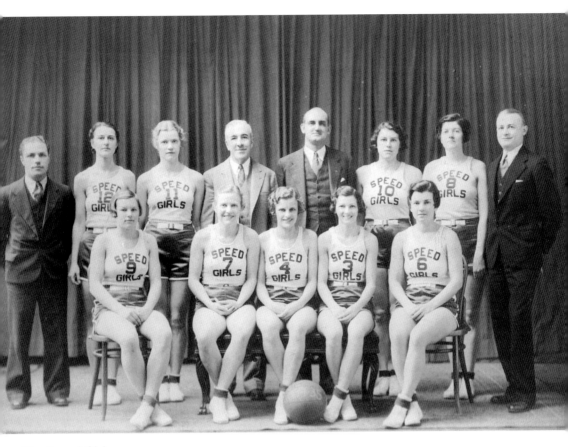

The Speed Girls

The Speed Girls of Middletown were a semiprofessional basketball team that played during the Great Depression. One of the best-known Speed Girls was Helen "Babe" Carlson. After graduating from Woodrow Wilson High School, where she was a basketball forward and a softball pitcher, she played with the Speed Girls for two years and was a pitcher and an infielder on men's hardball baseball teams in New Hampshire and Florida. This led to a story about her on the *Ripley's Believe It or Not!* radio program. In 2003, Babe Carlson (seated first row, at left) was inducted into the Middletown Sports Hall of Fame. Pictured here is the 1935–1936 Speed Girl team. Emma Anderson McMeken, one of the top players, is second from the left in the first row (No. 7). The team was sponsored by Jack's Lunch, whose proprietor, Jack Fitzgerald, invented the steamed cheeseburger. (Courtesy Middletown Sports Hall of Fame.)

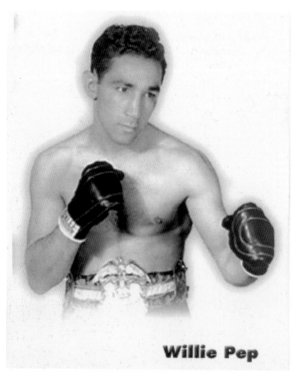

Willie Pep

Willie Pep: One of the Top Boxers in History
Often rated one of the top 10 professional boxers of all time, Middletown native Willie Pep (born Guglielmo Papaleo) finished his 26-year-long career with a record of 229-11-1 with 65 knockouts. When Pep fought Sandy Saddler for the featherweight title in 1948, Pep's record was 134-1-1. Pep passed away in 2006. In the photograph below, Willie Pep and world heavyweight champion Muhammad Ali are reading Pep's newly published book. (Courtesy Mary and William Papaleo Jr.)

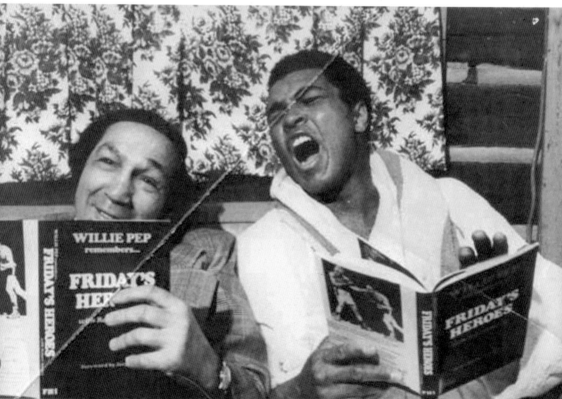

Tony Falco: More Than Just Willie Pep's Cousin

Middletown-born cousin of boxing great Willie Pep, welterweight Corrado J. "Tony" Falco fought professionally from 1941 through 1948. His training started at age 16 when he came home crying after being beaten up. His father purchased a punching bag and installed it in their kitchen. A couple of years later, Falco began fighting as an amateur, losing only once in 69 fights. Later, in the Air Force, he never lost a fight. Returning to civilian life, he turned professional and proceeded to a record of 67-11-6. Of his 67 wins, 23 were by knockout. Unfortunately, because he did not have connections, he was never given a shot at a world title. Quitting boxing at age 27, he became a toolmaker and machinist for Pratt & Whitney in Middletown. Three decades after leaving boxing, Falco told a *Hartford Courant* reporter that he was always financially better off as a toolmaker than at any time as a professional prizefighter. He passed away in 2001 at age 79. (Courtesy Middletown Sports Hall of Fame.)

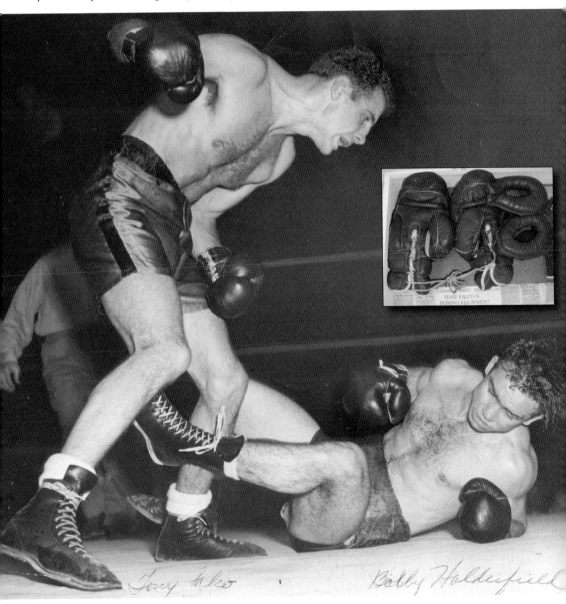

Phil Murphy: Xavier Star
After excelling in football and track at Middletown's
Xavier High School and at South Carolina State
University (1976–1980), Phil Murphy played
professional football for two seasons with the Los
Angeles Rams. At Xavier, he was also known for
his skill at the shot put and the hammer throw.
(Courtesy Middletown Sports Hall of Fame.)

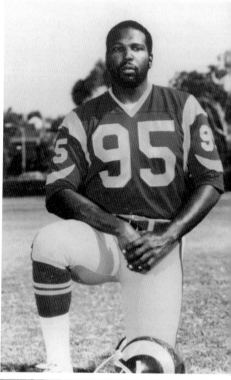

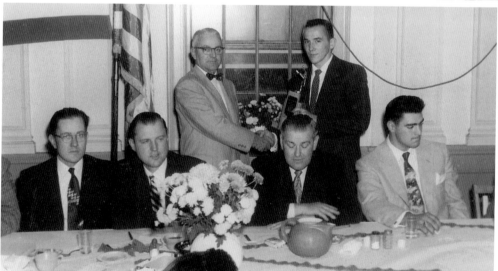

Joey Jay: The Yankees' Worst Nightmare
Born in Middletown in 1935, starting pitcher Joseph "Joey" Jay was the first Middletown Little League
player to join a major-league team. His career in the majors lasted 13 years and included stints with
the Milwaukee Braves, the Cincinnati Reds, and the Atlanta Braves. In his best years, 1961 and 1962, he
won 21 games for the Reds. In 1961, he was the only Reds pitcher to win a game when they took on the
Yankees in the World Series. In this photograph, taken at the 1953 Ahern Whalen Banquet, Jay is seated
at far right. (Courtesy Middletown Sports Hall of Fame.)

Bill Denehy: Major-League Pitcher
A top baseball and basketball player at Woodrow Wilson High School, Bill Denehy (b. 1946) went on to play both sports at St. Bonaventure College. Signing with the New York Mets in 1965, he pitched for the Mets, the Washington Senators, and the Detroit Tigers. After his final game in 1971, he coached for Boston Red Sox farm teams in Connecticut, was head baseball coach at the University of Hartford, and hosted radio sports programs. He was the second former Middletown Little Leaguer to go on to play Major League Baseball. (The first was Joey Jay.) Denehy was inducted into the Middletown Sports Hall of Fame in 1995. (Courtesy Middletown Sports Hall of Fame.)

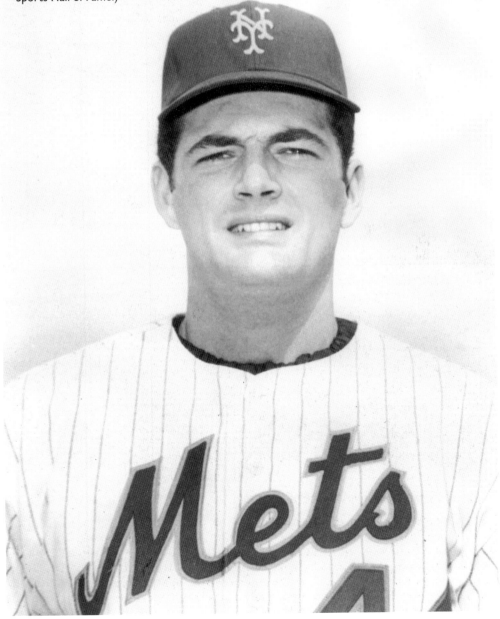

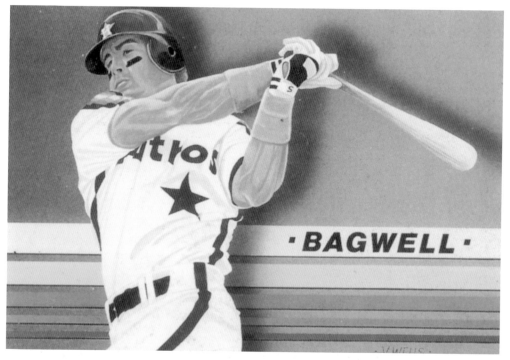

Jeff Bagwell: National League's Most Valuable Player
Born in 1968, Jeff Bagwell is a graduate of Middletown's Xavier High School, where he excelled at baseball, basketball, and soccer. He played for Middletown's American Legion Post 75 before playing first base for the Houston Astros for 15 straight years (1991–2005). During his Major League career, he was an all-star four times (1994, 1996, 1997, 1999) and in 1994 was named the National League's Most Valuable Player. In 2007, a year after he left the Astros, his number (5) was retired. (Courtesy Middletown Sports Hall of Fame.)

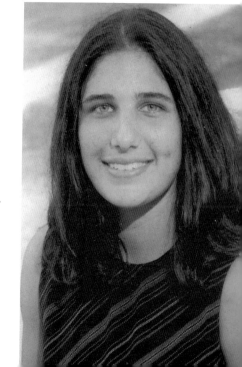

Jennifer O'Brien: Mercy High School Basketball Star
Jennifer O'Brien was named Connecticut Player of the Year by *USA Today* in 1996. At Davidson College (1996–2000), she was a three-time team captain and the career leader in points, assists, and free throws. She was also the Southern Conference's leader in steals for four seasons and in assists for three seasons. (Courtesy Middletown Sports Hall of Fame.)

Mark DeJohn

Born in Middletown in 1953, Mark DeJohn is a professional baseball coach and field coordinator of instruction for the St. Louis Cardinals' farm system. After playing baseball for Woodrow Wilson High School and Middletown's American Legion Post 75, he was acquired by the Detroit Tigers in 1982. DeJohn was the third Middletown Little Leaguer to enter the major leagues, after Joey Jay and Bill Denehy. (Courtesy Middletown Sports Hall of Fame.)

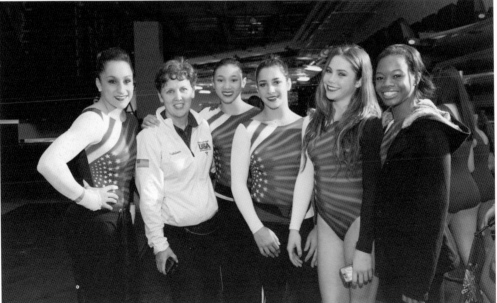

Kathleen Hickey Kane

Kane played for Mercy High School from 1978 through 1981, earning 11 varsity letters. A former New England Patriots cheerleader, she was also the state open balance beam champion in 1980. Kane has been on the USA Gymnastics medical staff for 25 years. Today, she works with young gymnasts as a physical therapist in Middletown. In this photograph, Kane (second from left) is shown on a tour with the Fab 5 (or Fierce Five), the gold-medal-winning 2012 US Olympic Women's Gymnastics Team. (Courtesy Kathleen Hickey Kane.)

The Hickeys: Hall of Fame Family

One of the top sports families of Middletown, the Hickeys can boast of four members having been inducted into the Middletown Sports Hall of Fame. Jay Hickey (inducted 2001) was a Xavier High School football and baseball star (graduated 1976) who became captain of the Brown University football and baseball teams and coached football at Xavier for 12 years. Kathleen Hickey Kane (inducted 2003) was a four-sport athlete at Mercy High School (graduated 1981) who went on to work with the USA Gymnastics Team (see page 37). Charles Hickey (inducted 2005) was a Xavier football and baseball star (graduated 1982) who, since 1999, has been head baseball coach for Central Connecticut State University. Christine Hickey Fritz (inducted 2013) was a three-sport star at Mercy (graduated 1988) and a volleyball and softball star at Eastern Connecticut State University. The Hickey family members shown here are, from left to right, (first row) Maribeth, mother Barbara, and Phyllis; (second row) Jay, Christine, Kathleen, and Charles. The six siblings played a total of 59 seasons of high school sports and were awarded 49 varsity letters.

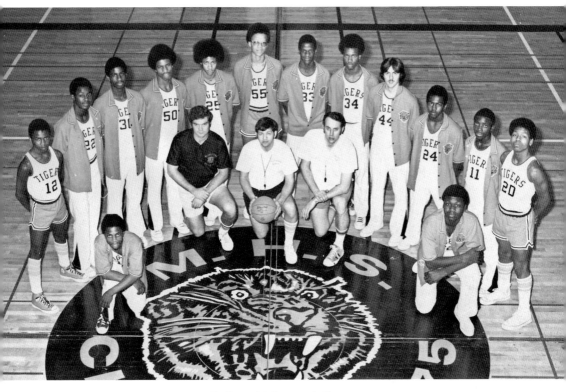

Corny Thompson and Thomas LaBella: Middletown's Stars

Born in Middletown in 1960, Cornelius "Corny" Thompson was captain of Middletown High School's varsity basketball team in his sophomore through senior years. During that time, the team won 76 games in a row, three consecutive league titles, and three state championships. Thompson then went on to the University of Connecticut, where he led the team in scoring for all four of his years (1978–1982). He ended with 1,810 points and 1,017 rebounds. He went on to play professional ball for the Dallas Mavericks and for top professional teams in Italy and Spain. In this photograph of the 1975–1976 Middletown High team, Thompson is kneeling at lower right.

Thomas LaBella was an outstanding athlete in basketball, baseball, and football at Middletown High School (1960–1964). He lettered in basketball and baseball at Central Connecticut State University, which he attended from 1964 to 1968. Later, he played semiprofessional baseball and served Middletown High as a teacher, coach, and coordinator of guidance. Between 1987 and 1994, he was assistant basketball coach at Wesleyan University. LaBella is kneeling at center, holding the ball. (Courtesy Middletown Sports Hall of Fame.)

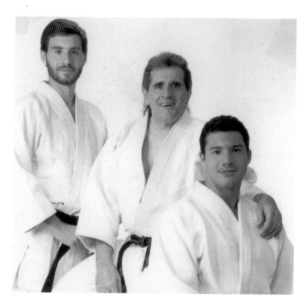

Louis LaPila: Middletown's Sensei

For 52 years, Louis LaPila has been teaching judo for the Middletown Judo Club at the YMCA. Since 1973, he has been sensei of the club and has made 43 promotions to various degrees of black belt (Shodan to Yodan). The winner of many tournaments and trophies, LaPila was inducted into the World Martial Arts Hall of Fame in 1996 as a sixth degree (Rokudan) black belt in judo and a fifth degree (Godan) black belt in jujitsu. In 2006, he was inducted into the Middletown Sports Hall of Fame.

Despite his remarkable career, LaPila is most comfortable discussing the accomplishments of his students. The three mottos he passes on to them are:

1. You do not have to be the best, but you have to do your best.
2. I'm not here to show you how good I am. I'm here to show you how good I can make you be.
3. Knowledge is responsibility.

LaPila is proud of his assistant instructors: Pasha Shoposhnikov and Chase Cutler (4th degree); Dan LaPila and Greg Makuch (3rd degree); and Chuck Burns, Joel Berry, and Mike Boise (2nd degree).

Today, his son Daniel helps him with his judo classes. Pictured above are LaPila (center) with his sons, Wesley (left) and Daniel. Below, he appears with some of his most recent students. (Courtesy Eleanor LaPila.)

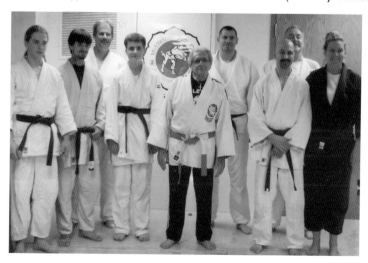

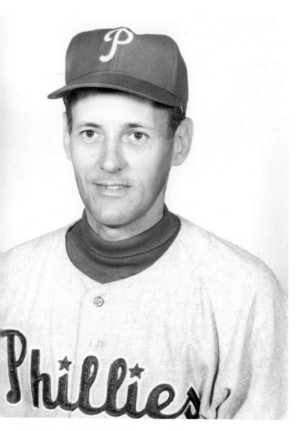

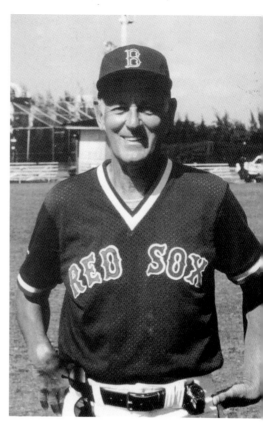

Bob Fralick: Major League Scout

A Marine veteran of World War II, Robert "Bob" Fralick was wounded in the invasion of Peleliu Island in 1944 and sent home for a series of operations. He went back to school and was awarded the Purple Heart while still a high school senior. In the early 1950s, Fralick attended college, met his future wife, and became a scout for the Philadelphia Phillies. After 14 years, he moved to Middletown in 1969 and scouted and coached for the Boston Red Sox and the New York Mets for 18 years. His long career also includes working as an assistant baseball coach for the Bristol and New Britain Red Sox and the founding of a baseball training camp for Middletown-area children. In 2010, Fralick was inducted into the Middletown Sports Hall of Fame.

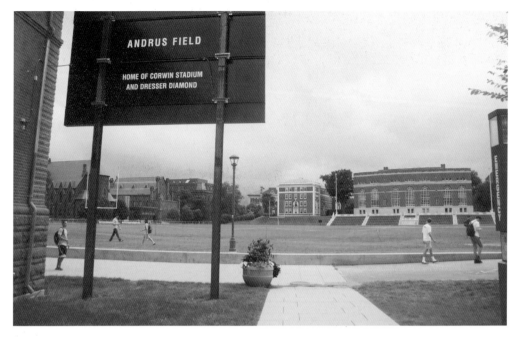

John Biddiscombe: Director of Athletics

Before serving as director of athletics at Wesleyan University (1988–2012), Biddiscombe had accumulated a lengthy resume. He was wrestling coach at Wesleyan from 1974 to 1989, defensive coordinator of the football team from 1974 to 1987, and assistant outdoor track coach from 1975 through 1984. This photograph of Wesleyan's Andrus Field shows the Olin Library in the distance. (Courtesy Middletown Sports Hall of Fame.)

Karina Lago: Top Student and Athlete

At Middletown High School, Uruguay-born Karina Lago was a championship runner in cross country, as well as an indoor track and softball star. She went on to graduate from Brown University where she was elected to Phi Beta Kappa. In 1995, she was killed while running near Tufts University, where she was pursuing a graduate degree at the Fletcher School of Law and Diplomacy. In 2014, she was posthumously named to the Middletown Sports Hall of Fame.

CHAPTER THREE

The Arts

The Middletown valley has been home to many artists, actors, musicians, and writers who found the city an ideal place to explore their talents. Young people and their elders have developed their imagination through nonprofit organizations like Oddfellows Playhouse, the largest year-round Connecticut youth theater, which teaches new skills while building self-confidence and teamwork; Artfarm, a professional theater company committed to social action and environmental awareness, currently led by Dic Wheeler and Marcella Trowbridge; Wesleyan Potters, a cooperative guild founded in 1948 that teaches and develops craft skills (pottery, jewelry, and weaving); and Vinnie's Jump & Jive, a community dance hall founded in 2000 by the Community Health Center Inc. that uses dance as a healthy, creative way to learn, have fun, and interact socially. It was named after toy store founder Vincent Amato, who donated the first dance hall space.

In addition to the artists recognized in this chapter, the following should also be acknowledged: Juliette Augusta Magill Kinzie (1806–1870), a pioneer and writer best known for her accounts of Native Americans and European settlers of the American Midwest; William Ranney (1813–1857), who created paintings of Western life; Alton Tobey (1914–2005), a painter, muralist, portraitist, illustrator, and teacher; Bill Watrous (b. 1939), who has been, since the 1960s, one of the best-known jazz trombonists in the country; and Neely Bruce, the only pianist who has played the entire repertoire of American composer Charles Ives.

Other artists born here who achieved success in the entertainment field include Academy Award–nominated director and screenwriter Jules Dasson (1911–2008), whose popular movies *Never on Sunday* (1960) and *Topkapi* (1964) starred his wife, Melina Mercouri; actress Emily Johnson (b. 1975), who is best known for *Beowulf* (2007); and animator Tim Pixton (b. 1978), whose works include *Alvin and the Chipmunks* (2009), *The Smurfs* (2011), *Life of Pi* (2012), and *Transylvania* (2012).

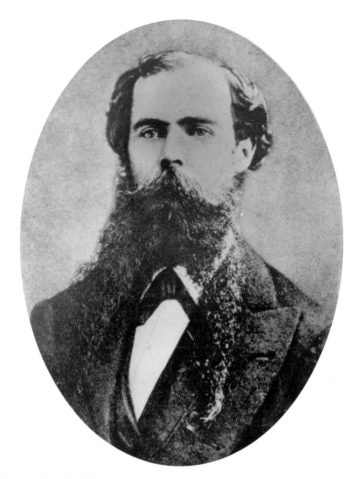

Henry Clay Work: The Civil War's Greatest Composer

Born in Middletown in 1832, Henry Clay Work moved with his family to the Midwest three years later. His father was jailed for several years for his antislavery activities. When Henry was 13, they returned to Middletown, where he finished his education. After apprenticing for a Hartford printer, he moved to Chicago, where he became a songwriter for the music publisher Root & Cady, eventually writing one of the most popular songs of the Civil War, "Marching Through Georgia." He followed it up in 1876 with the bestselling "My Grandfather's Clock." Its beginning lyrics are:

My grandfather's clock was too large for the shelf,
So it stood ninety years on the floor;
It was taller by half than the old man himself,
Though it weighed not a pennyweight more.
It was bought on the morn of the day that he was born,
And was always his treasure and pride;
But it stopped short never to go again
When the old man died.

This song became one of the most popular pieces of its day and, according to the Oxford English Dictionary, was responsible for the tall-case, weight-and-pendulum clock being named the grandfather clock. Henry Clay Work died in 1884. In 1917, a bust of Work was erected near his home on Mill Street and later moved to Main Street's South Green, across from the South Congregational Church.

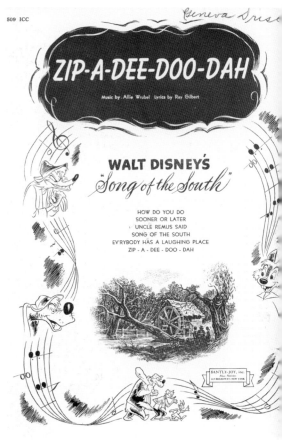

Allie Wrubel: Middletown's Answer to Irving Berlin

Born in Middletown in 1905, young Allie Wrubel helped out in his family's popular women's apparel store on Main Street, but his main interest was music. After graduating from Wesleyan University, he went to Hollywood. From 1934 to 1946, he was under contract with Warner Bros. to write songs for movie musicals. In the late 1940s, he began writing songs for such movies as Jennifer Jones's *Duel in the Sun*, and Burt Lancaster's *I Walk Alone*. In 1948, Wrubel's song "Zip-a-Dee Doo-Dah" won the Oscar for best song. He was inducted into the Songwriters Hall of Fame in 1970. Wrubel died in 1973.

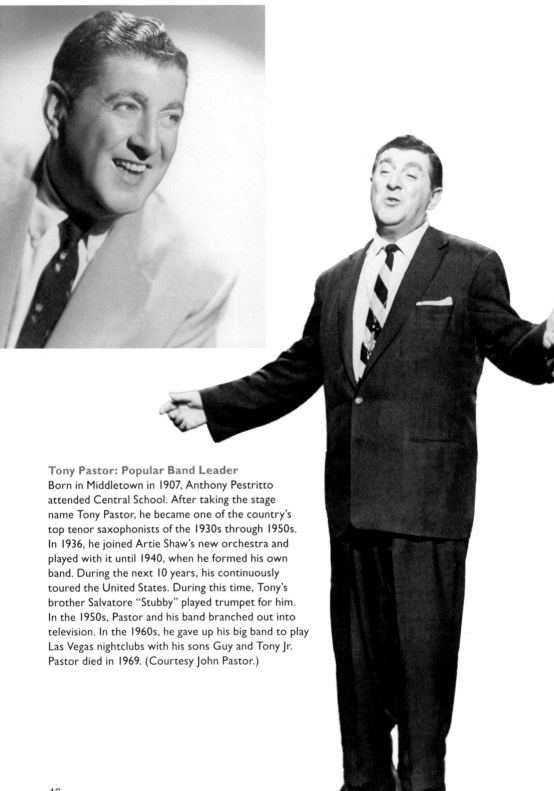

Tony Pastor: Popular Band Leader
Born in Middletown in 1907, Anthony Pestritto
attended Central School. After taking the stage
name Tony Pastor, he became one of the country's
top tenor saxophonists of the 1930s through 1950s.
In 1936, he joined Artie Shaw's new orchestra and
played with it until 1940, when he formed his own
band. During the next 10 years, his continuously
toured the United States. During this time, Tony's
brother Salvatore "Stubby" played trumpet for him.
In the 1950s, Pastor and his band branched out into
television. In the 1960s, he gave up his big band to play
Las Vegas nightclubs with his sons Guy and Tony Jr.
Pastor died in 1969. (Courtesy John Pastor.)

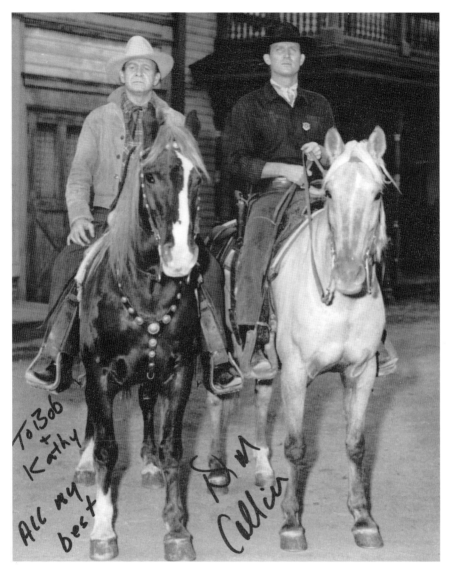

Barton MacLane: *I Dream of Jeannie*'s General

Born in 1902 in South Carolina, Barton MacLane moved to Cromwell, Connecticut, at age seven and graduated from Middletown High School in 1921. He went on to Wesleyan University, where he played football, basketball, and baseball. His biggest moment at the school occurred in 1924, when he made a 100-yard kickoff return. The publicity from this led to his first film role, as a football player in the 1926 silent movie *The Quarterback*. He then had an uncredited part in the Marx Brothers' first film, *The Cocoanuts*. MacLane steadily built up his career over the next four decades, working on stage, in movies (over 120 films), and on television. He had his own series in 1960, *The Outlaws*, costarring with Don Collier. In the 1940s, he appeared in supporting roles in a string of Humphrey Bogart classics: *The Maltese Falcon, All Through the Night, High Sierra*, and *The Treasure of the Sierra Madre*. McLane was the perfect tough guy, playing police captains, mobsters, and Western outlaws. In his later years, he owned a ranch in California, raising cattle and horses. Today, he is perhaps best known for his recurring role as Gen. Martin Peterson on Barbara Eden's *I Dream of Jeannie* television series. MacLane, who was born on Christmas Day, died on New Year's Day in 1969. MacLane (left) and Collier are seen here on the set of *The Outlaws*.

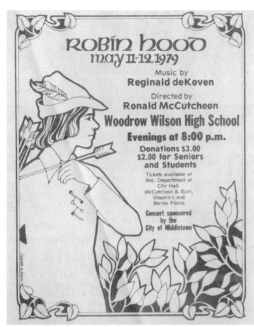

Reginald De Koven: Brilliant Composer

Middletown native Reginald De Koven (1859–1920) was both a music critic and composer. He specialized in comic operas in the style of Gilbert and Sullivan. His song "Oh Promise Me" was a standard wedding song for decades and was featured in Eddie Murphy's 1989 movie *Harlem Nights*. This 1979 advertisement announces a local production of De Koven's most popular work, *Robin Hood*. It was directed and produced by Ronald M. McCutcheon. (Courtesy Ronald W. and Lois McCutcheon.)

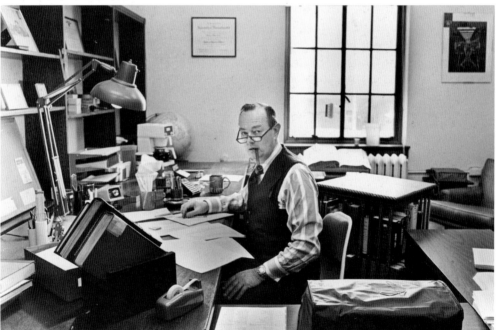

William Manchester: Wesleyan Writer-in-Residence

An editor, adjunct professor of history, and a writer-in-residence at Wesleyan University, William Manchester is best known for his biographies of world leaders, including Gen. Douglas MacArthur and Winston Churchill. His most famous work, *The Death of a President*, was an account of Pres. John F. Kennedy's assassination. In 1964, he was commissioned by Kennedy's widow, Jacqueline, to write an account of the 1963 tragedy. The book was released in 1967 and became an international bestseller. Manchester died in 2004 at age 82. (Courtesy Wesleyan University.)

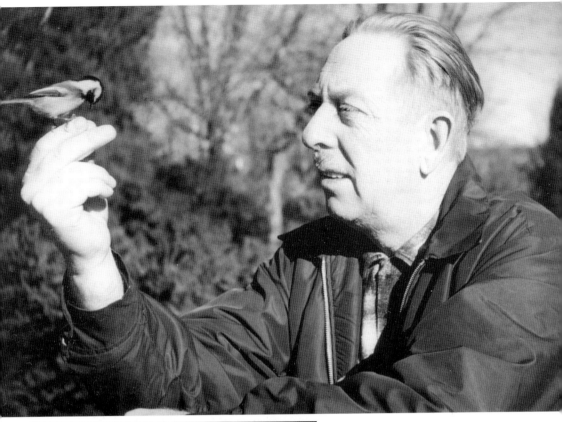

Albert McCutcheon:
Celebrated Muralist
Born in Middletown in 1901, Albert
McCutcheon studied at the Yale School
of Fine Arts and the Julian Academy
in Paris (1923). In the 1930s, he was
commissioned by the Works Progress
Administration to paint murals and
easel paintings for public buildings,
including the *Epic of Middletown*
murals for Woodrow Wilson High
School (1936) and a mural for the
kindergarten room at Eckersley Hall
School. In the c. 1960 photograph
at left, Albert (standing, right) plays
with his brothers Ron (standing, left)
and Ernest. (Above, courtesy Janet
McCutcheon Batt; left, courtesy
Ronald W. and Lois McCutcheon.)

49

David Webb Peoples: Top Screenwriter
Raised in Middletown, screenwriter David Webb Peoples studied at the University of California at Berkeley. In 1992, he had three of his movies in theaters at the same time: Clint Eastwood's Oscar-winning *Unforgiven*, Stephen Frears's *Hero*, and the rerelease of Ridley Scott's *Blade Runner*. Other works by Peoples include *Twelve Monkeys*, which he wrote with his wife, Janet Peoples, and *The Blood of Heroes*. (Courtesy Janet Peoples.)

Richard Slotkin: Cultural Critic and Historian
Richard Slotkin is Olin Professor of English and American Studies, emeritus, at Wesleyan University, where he played an important role in the creation of the school's American studies and film studies programs. He is also the author of a trilogy on the myth of the frontier in America (*Regeneration Through Violence*, *The Fatal Environment*, and *Gunfighter Nation*) and three historical novels. His latest work is *The Long Road to Antietam: How the Civil War Became a Revolution*. (Courtesy Wesleyan University.)

Alvin Lucier: Composer of Experimental Music
Lucier was the John Spencer Camp Professor of Music at Wesleyan University, where he has taught for over 40 years. He is known as a major composer of experimental music and has studied brain waves, performers' physical gestures, and room acoustics. He has performed and lectured throughout the United States, Europe, and Asia. (Courtesy Amanda Lucier.)

David Garry: Versatile Actor
Middletown-born David Garry (born David Gary Johnson Jr.) has acted in commercials, film, and television, including the recurring role of Hanrahan in *Just Shoot Me!* In addition, he has often worked as a stand-in for actor David Spade. Besides his professional work, Garry is a coordinator of volunteers for Camp Ronald McDonald for Good Times, a year-round camp that provides medically supervised, cost-free camp programs for children with cancer and their families. In 2013, he produced and starred in the short film *The Man Who Loved His Cat.* (Courtesy David Garry.)

Santo Fragilio: Legendary Music Teacher
Growing up in Middletown, Santo Fragilio attended Macdonough School, Central School, and Middletown High School. In 1948, after graduating from the Hartt College of Music and the University of Connecticut, he accepted a position as Middletown High's band director and music instructor for grades three to twelve. In 2013, the school district honored Fragilio for 65 years of service. Still going strong, Fragilio is busy working on the district's curriculum and arranging trips for music students.

Anthony Braxton: Multidimensional Musician
Anthony Braxton is the John Spencer Camp Professor of Music at Wesleyan University, teaching courses on music composition, music history, and improvisation. He is a composer, saxophonist, clarinetist, flautist, and pianist. In announcing Braxton as one of its 2014 Jazz Masters, the National Endowment for the Arts stated, "Anthony Braxton's compositions almost defy categorization through his use of the improvised and rhythmic nature of jazz, but moving it in a more avant-garde direction." (Courtesy Wesleyan University.)

CHAPTER FOUR

Government Leaders and Educators

Middletown has long been a leader in providing primary, secondary, and postsecondary education. This chapter highlights public-school teachers, college and university professors, and college presidents. It also includes people who devoted their lives to government and community service in such positions as prosecuting attorneys, police and fire chiefs, mayors, state legislators, judges, members of Congress, governors, and even a president of the United States. They are young and old, men and women, Democrats and Republicans. What they all have in common is that they served Middletown to the best of their abilities and reached the level of legendary locals.

Additional people deserving mention in this chapter are Samuel Dickinson Hubbard (1799–1855), a US postmaster general under Pres. Millard Fillmore; William Michael Citron (1896–1976), veteran of World Wars I and II and two-term Connecticut congressman; Harry Edelberg (1917–1998), attorney and judge; and Charles Wilbert Snow Jr. (1923–2012), a longtime board of education chairman who practiced law in Middletown for over 50 years.

In addition to the several Middletown mayors spotlighted here, there is Asher Miller, who holds the longevity record of 29 years as mayor of Middletown (1792 through 1821). Since the first mayor was elected in 1784, no other holder of that office has been mayor for longer than 10 years.

Due to page constraints, it is not possible to provide separate entries on every deserving person.

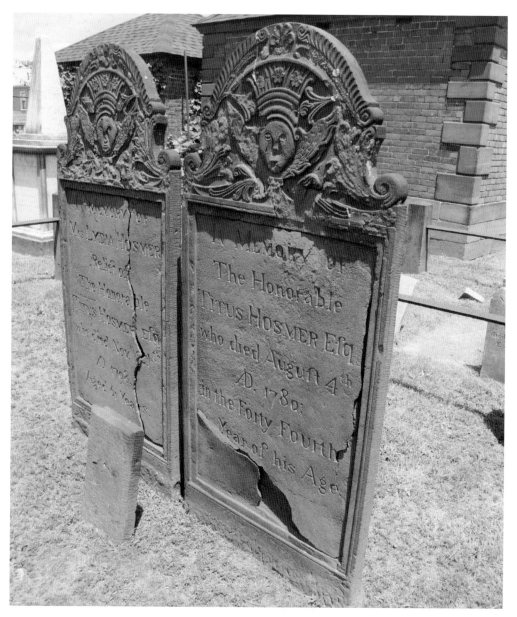

Titus Hosmer: Delegate to the Continental Congress

Hosmer was born in West Hartford, Connecticut, in 1736. After graduation from Yale College in 1757, he studied law and opened a legal practice in Middletown. He was a member of the Connecticut House of Representatives during the first years of the American Revolution, serving as its speaker. In 1778, Hosmer was sent to the Continental Congress, where he joined Roger Sherman and three other Connecticut delegates in signing the Articles of Confederation. He served as a state senator from 1778 until his death in 1780 at age 44. Lexicographer Noah Webster wrote that he considered Titus Hosmer one of the three greatest men Connecticut ever produced. (The others were the first two US senators from Connecticut: Oliver Ellsworth, who became chief justice of the Supreme Court; and William Samuel Johnson, who signed the US Constitution.) Shown here is Hosmer's grave marker in Middletown's Mortimer Cemetery. (Courtesy Todd Austin.)

Owen Vincent Coffin: Connecticut Governor

Son of a farmer, Owen Vincent Coffin (1836–1921) accepted a salesman job in New York City at age 17. After gaining work experience, he moved to Middletown about 10 years later and held a series of important business positions: president of the Middlesex Mutual (Fire) Assurance Company; secretary and treasurer of the Farmers & Mechanics Savings Bank of Middletown; and president of the Middlesex County Agricultural Society. In the political arena, he served as mayor of Middletown (1872–1873) and as a state senator. In 1894, he was elected governor of Connecticut, the first citizen of Middlesex County to hold that post. During his time as governor, bills were passed prohibiting the employment of children under the age of 14, affirming a worker's right to join a labor union, and prohibiting the use of convict labor in the production of food, drugs, and tobacco products. Although not a college graduate, Coffin received an honorary LLD degree from Wesleyan University.

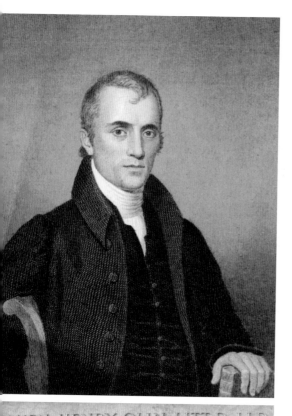

Willbur Fisk: Wesleyan University's First President

A Methodist minister and graduate of Brown University, Willbur Fisk was appointed the first president of Wesleyan in 1830. In his inaugural address, he gave an indication of his philosophy: "Education should be directed in reference to two objects—the good of the individual educated and the good of the world." He was serving as president when he died in 1839 at age 46. The university's Fisk Hall, which was built in 1903, is named after him. (Courtesy Wesleyan University.)

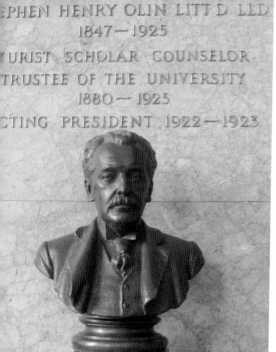

PHEN HENRY OLIN LITT D LLD
1847 — 1925
URIST SCHOLAR COUNSELOR
TRUSTEE OF THE UNIVERSITY
1880 — 1925
TING PRESIDENT 1922 — 1923

Stephen Olin: The Olin Library

Born in 1797, Stephen Olin was a Methodist Episcopal Church minister who became the third president of Wesleyan University (1842–1851). Over six feet in height, he was known as a captivating speaker. Often in fragile health, he died in Middletown in 1851. This bust is located at the university's Olin Library, which is named for Stephen Olin and his son, Stephen H. Olin, who was in the 1886 graduating class.

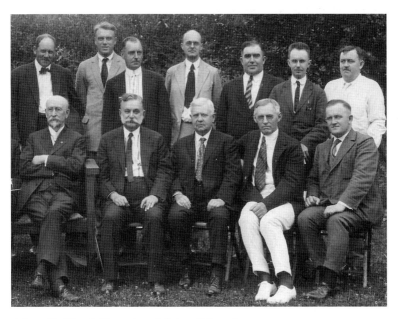

Charles and Amelia Vinal: Vocational School Benefactors

After graduating from Wesleyan University in 1861, Charles G.R. Vinal (1840–1926) served as a first lieutenant in the American Civil War. After the war, he studied law and was appointed clerk of superior court for Middlesex County, a position he held for about half a century. Beginning in 1901, he was Connecticut's secretary of the state for four years. After Vinal and his wife, Amelia Hotchkiss Vinal (1842–1931), donated the land for the construction of a technical high school, it was built on Church Street and opened with 13 students in 1925. In 1962, a new Vinal Vocational-Technical High School opened on 30 acres on Daniels Street. The above photograph shows members of the Middlesex County bar in 1921. Charles Vinal, 81 and goateed, is seated on the left. Future Connecticut governor Raymond Baldwin, here a 28-year-old student, is standing second from the left. Attorney Bertrand Spencer, 37, is standing second from the right. Today, both Vinal and Spencer have Middletown schools named for them.

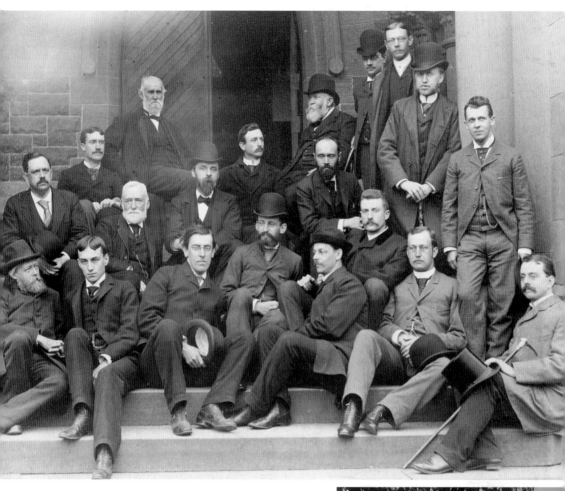

Woodrow Wilson: Professor to President
Woodrow Wilson was the 28th president of the United States and a Wesleyan University professor from 1888 to 1890. His daughter Eleanor was born in Middletown while he taught at Wesleyan. While at the school, Wilson organized student debates in a British House of Commons format in an effort to demonstrate the parliamentary system, which he proclaimed was superior. After leaving Middletown, Wilson became president of Princeton University (1902–1910), governor of New Jersey (1911–1913), and US president (1913–1921). The Wilsons lived in Middletown in a wooden house on High Street, near the intersection with Church Street. It was torn down around 1908. In the above photograph, Wilson is in the first row, third from the left. The photograph to the right shows Middletown's former Woodrow Wilson High School, which was dedicated in 1931, seven years after the president's death. (Above, courtesy Wesleyan University.)

Ida Keigwin: Dedicated Teacher
Born in Scotland, Connecticut, in 1866, Ida Keigwin began teaching students at age 16, following her parents' profession. After graduating from Willimantic Normal School, she joined Middletown's Johnson School, teaching from 1902 to 1937. At age 71, she devoted her life to fostering world peace and supporting missionary work. Keigwin Middle School, located in the Newfield section of Middletown, honors her as a dedicated educator who promoted learning beyond the "three Rs." She died at age 87, after teaching for more than 50 years. (Courtesy Keigwin Middle School.)

Van Buren Moody: District Superintendent
Born in 1885, Van Buren Moody was superintendent of the Middletown School District from the 1920s until his retirement in 1953. During part of that time, he was also superintendent of Portland schools. One of the major accomplishments of his administration was the opening of Woodrow Wilson High School in 1931. Van Buren Moody Elementary School on Country Club Road, which opened in 1964, was named for him.

Bertrand E. Spencer: Attorney and Mayor

A graduate of the University of Maine Law School, Bertrand Spencer (1884–1941) came to Middletown in 1910. He practiced law for 30 years in the city, was a clerk of city court (1915–1917), a prosecutor (1919–1923), an assistant to the state's attorney (1918–1930), state's attorney for Middlesex County (1930–1940), and mayor of Middletown for the last few years of his life. Bertrand E. Spencer Elementary School, in the Westfield section of town, is named for him. Spencer is pictured in this 1939 photograph.

Philip D. Wheaton: First President of Middlesex Community College

Growing up in Putnam, Connecticut, Philip Wheaton worked for years as lecturer for the University of Maryland and administered its overseas division in Europe and the Far East. In 1966, he became the first president of Middlesex Community College. The college's Wheaton Hall is named for him. Here, Wheaton (left) is seen with former governor Wilbert Snow, who was a driving force behind the effort to establish the Connecticut community college system.

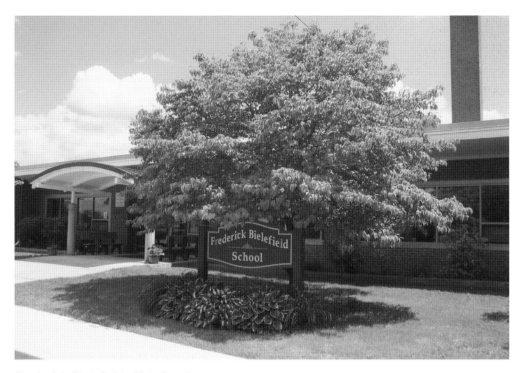

Frederick Bielefield: Civic Leader
As a four-term mayor (1927–1934), postmaster of Middletown (1935–1950), common council member, and longtime district school board member, Bielefield was one of Middletown's most active leaders. In 1954, the new Frederick J. Bielefield Elementary School was named after him. In addition to his extensive civic duties, Bielefield was an authority on bees, lecturing on them and raising them for years. He was born in 1872 and died at age 80.

Frances T. Nejako: Latin Teacher
Born in Middletown, Nejako was the eldest child of Polish immigrants. She was probably the first person of Polish descent to graduate from Wesleyan University. After teaching Latin in New Jersey for two years, she returned to Middletown and taught high school Latin for 47 years. She died in Middletown in December 1957. Nejako Drive in Middletown's Westfield section is named for Frances Nejako. (Courtesy Wesleyan University.)

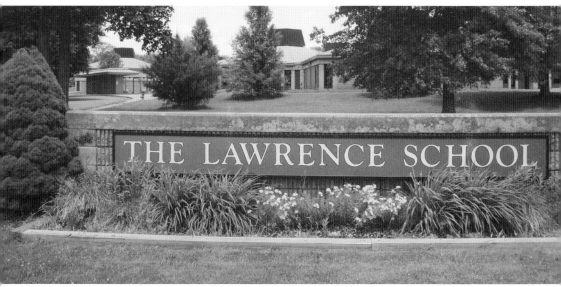

The Lawrence Sisters: 119 Years of Service

The Lawrence Elementary School on Kaplan Drive is named for three sisters: teachers Anne and Mary Lawrence, and school nurse Ruth Lawrence. The three of them served the city for a total of 119 years. At the school's opening ceremony in 1973, Mayor Anthony Sbona stated: "Quality education is synonymous with the name Lawrence." The two living sisters, Anne and Ruth, attended the event.

Colin Campbell: Wesleyan President

The youngest president in the history of Wesleyan University, Colin Campbell was 35 when he was selected in 1970. With a background at the American Stock Exchange, he was well suited to his first major task: increasing the financial stability of the school. Next, he set about reorganizing the alumni association and establishing and improving academic programs, including women's studies, earth and environmental sciences, African American studies, and East Asian studies. After leaving the university, Campbell became chairman and president of the Colonial Williamsburg Foundation.

Vivian McRae Wesley: Beloved Teacher

Vivian McRae Wesley, who died in 1970 at age 40, was a lifelong resident of Middletown. She attended local Middletown schools and obtained a BA in education from Hampton Institute in Virginia (1952), a fellowship from the Rockefeller Foundation, and her MA from Columbia University (1954). As an outstanding candidate, she was immediately hired by the board of education and was the second African American teacher employed by the city. (Caroline Hatcher was the first.) Wesley worked for more than 10 years as a classroom teacher, reading consultant, and director of reading (1965). Middletown physician Julie Flagg gave high praise and enormous credit to Wesley as "an immensely positive woman, with an exceptional gift to transform children into readers." After her workday was over, Wesley read aloud with Flagg for about three years, allowing Flagg to select any level book that interested her. Attorney Ted Raczka, currently a member of the Board of Education, attended public schools and still has vivid memories of Wesley. At age 10, Raczka attended her summer reading class to jumpstart his reading. He recalls her "gentle voice" and "we'll figure this out" commitment that made students confident they would improve. Wesley learned Raczka's interests—adventure books—and made such an impact on him that he can still recall what he read. She would be pleased to know that many of her students are still readers because she got them hooked on books. Whether by learning decoding skills or being instilled with confidence that Wesley would figure out the problem, many of her students were turned around academically. After her premature death, a new elementary school was opened in 1972 and named after her. Vivian McRae Wesley Elementary School was built on 15 acres of land located on Wesleyan Hills Road off Route 17.

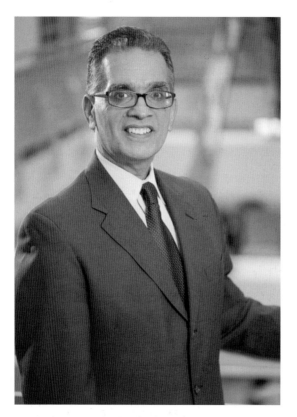

Wilfredo Nieves: College President
Nieves holds a doctorate of education in counseling psychology from Rutgers and served for 10 years as president of Middlesex Community College. Over the years, he has contributed his time to serve on the boards of directors of the National Coalition of Advocates for Students, the Community Renewal Team, Latino Community Services, and other community organizations. In 2010, Dr. Nieves was appointed president of Capital Community College. (Courtesy Wilfredo Nieves.)

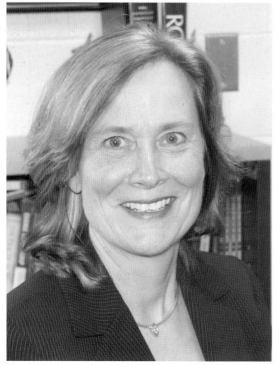

Patricia Charles: Superintendent of Middletown Public Schools
Before Dr. Charles became superintendent of Middletown Public Schools in 2012, she served as principal of Farm Hill School and Keigwin Middle School. One day in 1999, her father went to a doctor's appointment in Fairfield, Connecticut, and struck up a conversation with a woman in the waiting room. The woman said that her son was the superintendent of schools in Middletown. To which Pat Charles's dad exclaimed, "My daughter is a principal in the Middletown Public Schools and someday my daughter is going to have your son's job!"

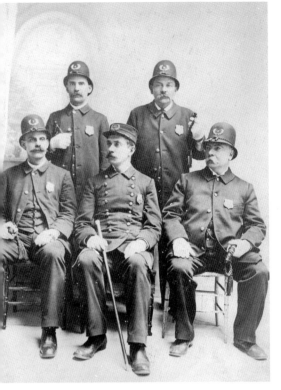

placed on probation,	5
bound over,	
appeals,	
cases continued,	3
delivered to out of town officers,	2
Judgment Suspended	12

OFFENCES	No.	MISCELLANEOUS DUTIES	N
Adultery,		Accidents reported,	
Assault,	10	Lost children found,	
Assault, intent to		Permits to carry weapons,	
Assault,		Store doors or windows open,	
Automobile law,		Obstructions on walks,	
Breach of peace,	6	Sidewalks or streets out of repair,	$160
Bicycle law,		Value of property found,	
Burglary,		Sick persons taken care of,	
Breaking and entering,		Junk dealer licenses issued,	
Carrying concealed weapons,		Lights reported out,	
Drunkenness,	10		
Resistance,			
Evading Probation,			
Evading payment R. R. fare,			
Indecent,			
Injury to property,			
Incorrigible,	1		
Insane,			
Non-Support,			
Theft,	3		
Theft of horse,			
Theft from person,			
Trespassing,			
Vagrancy,			
Violation of ordinances,	1		
Violation rubber tire law,			
Violation Sunday law,			
Violation liquor law,	1		
Discharging Fire arms	4		
Loitering	1		
Seduction	1		
False Pretense	1		

REMARKS:

Respectfully submitted,

AW. Inglis

CHIEF OF POLICE.

Archibald Inglis: Pioneer Police Chief

Lifelong Middletown resident Archibald W. Inglis became Middletown's police chief in 1893 and held the position until 1923. In addition to serving 31 years on the police force, he was a fireman with the Douglas Hook and Ladder Company. In the above photograph are, from left to right, (first row) Officer Joseph Kincaid, Chief Inglis, and Officer Patrick Ghent; (second row) unidentified (possibly Officer Thomas Kinsella) and Officer Addison Chapman. Shown on the right is Chief Inglis's monthly report of August 1910. (Right, courtesy Russell Library.)

Charles Anderson: Longtime Chief of Police

Born in Sweden in 1884, Charles Anderson worked for years at a Portland cigar-making company. In 1915, he was elected a Middletown councilman, and in 1923, he became chief of the town's eight-man police force. Stories are told of intoxicated people of the time being trucked to the police station in wheelbarrows and citizens earning a little money by driving arrested people to jail. It was under Chief Anderson that the department acquired its first typewriter (1925) and the city installed the first traffic lights. When he retired in 1949, the police department had grown to be one of the most professional forces in the state, with 33 officers and patrolmen. Among those honoring him at his farewell dinner was Yankees pitching great Vernon "Lefty" Gomez. Chief Anderson appears in the photograph to the right. Pictured below is one of his monthly police reports. (Below, courtesy Russell Library.)

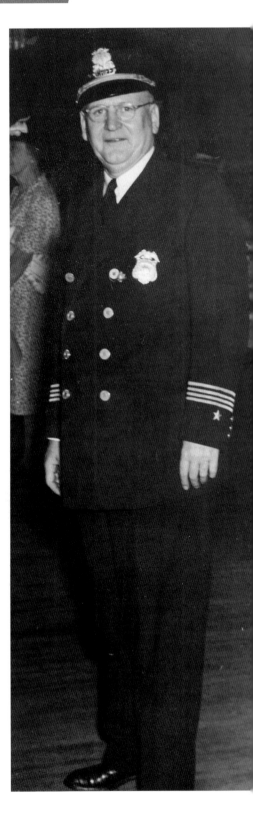

" Court	4	Trespassing	1
" Nolle	3	Vagrancy	1
Fines imposed	39	Violation city ordinances	3
Jail imposed	7	Violation motor vehicle laws	31
Placed on probation	6	Violation game laws	2
Bound over		Violation humane laws	
Appeals		Violation liquor laws	2
Turned over to out-of-town officer	4	Violation probation	
Judgment suspended	10	Violation dog laws	
Cases continued	2		
Bond Forfeited			
Committed to State Hospital	1		
Ordered out of town	3		
Bonds forfeited	3	OF THOSE WHO WERE ARRESTED	
		Married	44
OFFENSES		Single	40
		Males	78
Adultery		Females	6
Assault	2	American born	56
Assault Intent		Foreign born	28
Bigamy		Residents	45
Burglary		Non residents	39
Breach of peace	5	Minors	14
Carrying concealed weapons		**MISCELLANEOUS DUTIES**	
Contempt		Accidents reported	45
Drunkenness	18	Bank burglar alarms answered	1
Evading probation		Complaints investigated	186
Embezzlement		Defective highways reported	7
Enticing Minor Female		Fire alarms given	1
Evading personal tax		General reports filed	7
Frequenting disorderly house	14	Junk dealers licenses issued	
Frequenting gaming house		Lost children found	1
Fraud		Lights reported out	9
Gaming		Money taken from prisoners	$59.22
Indecent		Number of lodgers	30
Injury to property		Personal tax summons served	
Incorrigibility		Permits to carry concealed weapons	13
Interfering with an officer	1	Pay rolls protected	118
Insane		Permits for sale of revolvers	
Juvenile Delinquency		Permits to conduct pool-room	
Keeping disorderly house	1	Store door or windows open	17
Keeping gaming house		Sick persons taken care of	3
Lascivious carriage		Summoned for minor violations	14
Loitering		Value of property found and recovered	$2528.00
Murder			
Manslaughter			
Non-support			
Prostitution			
Resistance			
Rape			
Robbery	1		
Abandonment	1		

5 automobiles ~~recovered~~ stolen in Middletown. All recovered.
222 automobiles reported as stolen over the telephone typewriter.

Respectfully submitted,

Chas. A. Anderson
Chief of Police.

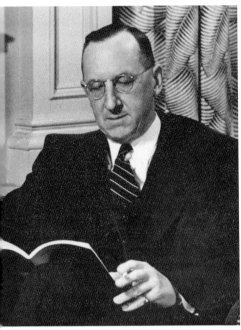

James L. McConaughy: President Becomes Governor

President of Wesleyan University for 18 years (1925–1943), James L. McConaughy (1887–1948) directed the construction of many important buildings on campus, including Olin Library, Hall Laboratory, and Shanklin Memorial Laboratory. He also served as lieutenant governor of Connecticut from 1939 to 1941 under Gov. Raymond Baldwin, a Wesleyan alumnus. In 1946, McConaughy was elected the 76th governor of Connecticut and served until his death.

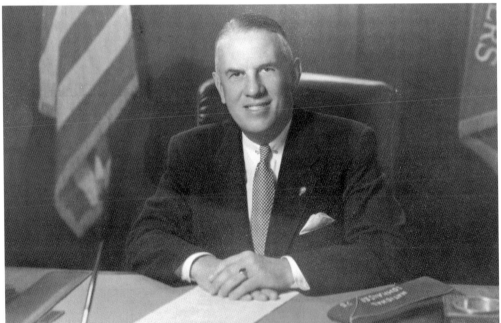

Arthur Connell: American Legion National Commander

In September 1953, World War I Navy veteran Arthur J. Connell became the first Connecticut person to be named the national commander of the American Legion. The following month, he returned home to Middletown, where he was honored by a parade attended by over 75,000 people and with 4,000 people marching under a sign reading "Welcome Home, Art." The parade included a 500-man corps from the Coast Guard Academy, Gov. John Davis Lodge, actor Edward G. Robinson, and five past American Legion commanders.

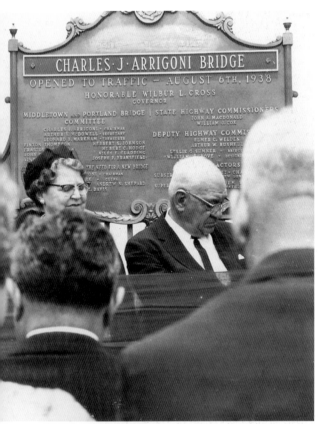

Charles Arrigoni: The Man and the Bridge

Although he was a state representative and a state senator from the neighboring town of Durham (1933–1940), Charles J. Arrigoni did more for Middletown than most of its resident leaders. More than anyone else, he was responsible for the construction (1936–1938) of the only automobile/pedestrian bridge that crosses the Connecticut River at Middletown. His efforts were so significant that, years later, the bridge was named after him. At left, Arrigoni is pictured with his wife at the 1963 ceremony to rededicate the bridge in his name.

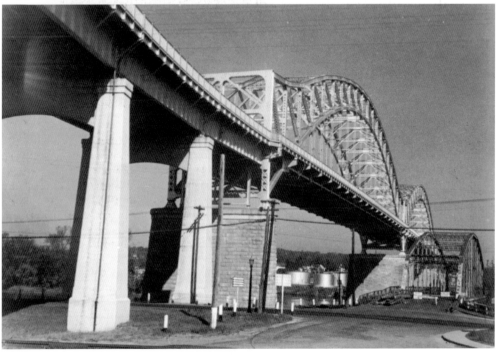

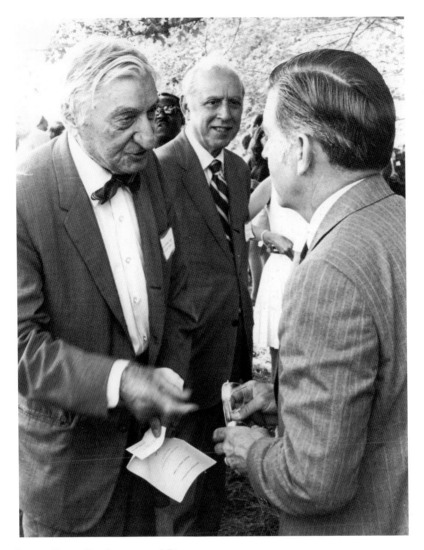

Wilbert Snow: Poet, Professor, and Statesman

Born in Maine a month before fellow New Deal Democrat Harry Truman, Wilbert Snow (1884–1977) was the son of a Coast Guardsman. He worked his way through college and earned a graduate degree from Columbia University. In early life, he was a lobsterman in Maine, a teacher of the Inuit people, a reindeer agent in Alaska, an artillery officer in World War I, and an instructor at several institutions of higher education. Professionally, Snow was perhaps best known for his 31 years as a literature professor at Wesleyan University. His devotion to his profession, his nationally acclaimed poetry, and his friendships with poets Robert Frost, Carl Sandburg, and Edna St. Vincent Millay made him a legend. Always active in politics, Snow served as lieutenant governor and, for 12 days, the 75th governor of Connecticut. He once said, "Everyone should be interested in politics. If the people stay out, the crooks will take over." Snow was a longtime member of the Board of Education, a key player in the establishment of Middlesex Community College, and, at age 81, a delegate to the state constitutional convention. In 1955, Middletown's newest elementary school on Wadsworth Street was named in his honor. When Snow passed away in 1977 at age 93, Gov. Ella Grasso said, "Perhaps his most lasting contribution will be the poetry in which he spoke so eloquently from his heart of his native New England and of those he loved." This early 1970s photograph shows Snow (left) speaking with Connecticut governor Thomas Meskill.

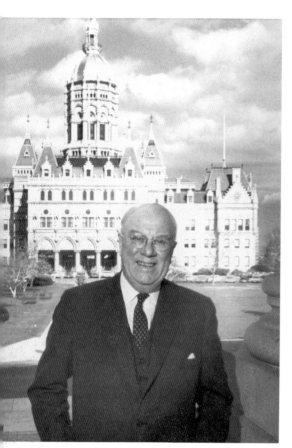

Raymond Baldwin: Governor, Senator, and Chief Justice

From the age of 10, Raymond E. Baldwin (1893–1986) attended public schools in Middletown. A graduate of Wesleyan University, he served as governor (1939–1941, 1943–1946), US senator (1946–1949), and as an associate justice (1949–1959) and chief justice (1959–1963) of the Connecticut Supreme Court of Errors. In his retirement years, Baldwin chaired the Connecticut Constitutional Convention in 1965. Governor Baldwin passed away in 1986 at age 93.

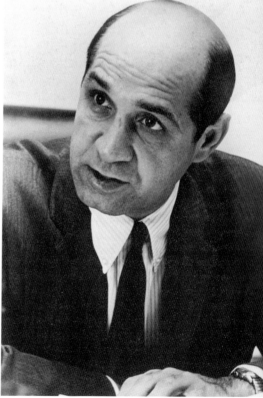

Emilio Daddario: Mayor, Judge, and Congressman

A 1939 graduate of Wesleyan University and a decorated veteran of World War II and the Korean War, Emilio Q. "Mim" Daddario (1918–2010) was mayor of Middletown from 1946 through 1948. From 1959 to 1971, he was a member of the US House of Representatives from Connecticut's First District. His committee assignments included chairmanship of the new Subcommittee on Science, Research, and Development. Daddario was 91 when he passed away in 2010.

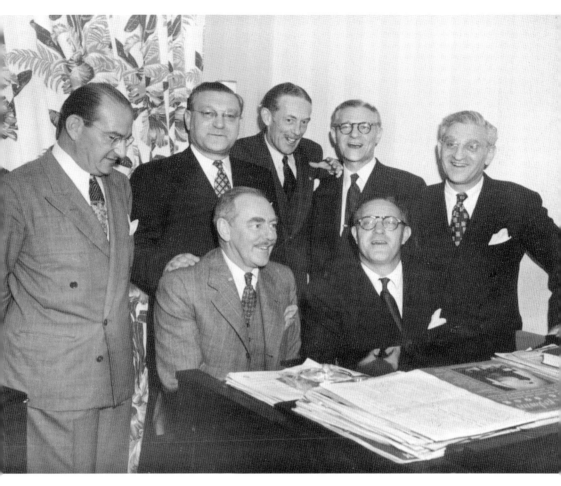

Dean Acheson: Truman's Secretary of State

Born in Middletown in 1893, Dean Acheson was the son of Edward Campion Acheson, rector of the Church of the Holy Trinity. After attending grammar school in Middletown, Dean attended the Groton School, Yale University, and Harvard Law School. He clerked for Supreme Court justice Louis Brandeis and joined a private law firm. In 1933, Pres. Franklin D. Roosevelt appointed him undersecretary of the treasury, beginning his 20-year-long career serving Presidents Roosevelt and Truman. In 1941, Acheson became assistant secretary of state for economic affairs, and in 1949, he was instrumental in the formation of the North Atlantic Treaty Organization (NATO). He was secretary of state throughout the Korean War. In later years, he was often called for advice and sat on the committee President Kennedy created to advise him on the 1962 Cuban Missile Crisis. Acheson died at the age of 78 in 1971. Acheson poses in this photograph with Middletown's Wrubel brothers. From left to right are (first row) Acheson and Allie Wrubel; (second row) Bernie and Arthur Wrubel, Dean's brother Ted Acheson, and Willie and Robbie Wrubel. (Courtesy Richard Wrubel.)

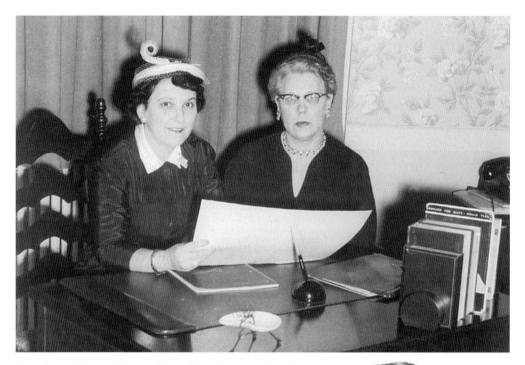

Joseph and Mary Adorno: Longtime Community Figures

Born in Middletown, Joseph A. Adorno (1912–1988) became state treasurer of Connecticut (1947–1955), deputy state attorney general, and a superior court judge. Upon reaching the mandatory retirement age of 70 in 1982, he stayed on as a state trial referee. Adorno (right) was a charter member of the Connecticut Judges Association and president of the Middlesex County and the Middletown Bar Association. He died in a car accident in 1988. His wife, Mary, was severely injured in the crash, but survived. She passed away in 2005. Always one to give generously of her time, Mary Adorno accumulated 5,570 hours of volunteer service to Middlesex Hospital. An active parishioner at St. Sebastian Church, she was a member of St. Theresa's Guild and the Middlesex Council of Catholic Women. She also raised money for the YMCA, the Cerebral Palsy Association, and countless other causes. In 1967, she was named Outstanding Woman of the Year by the local B'Nai B'rith chapter. In the 1956 photograph above, Mary (left) poses with Mrs. John F. Burns. (Right, courtesy Joan Adorno.)

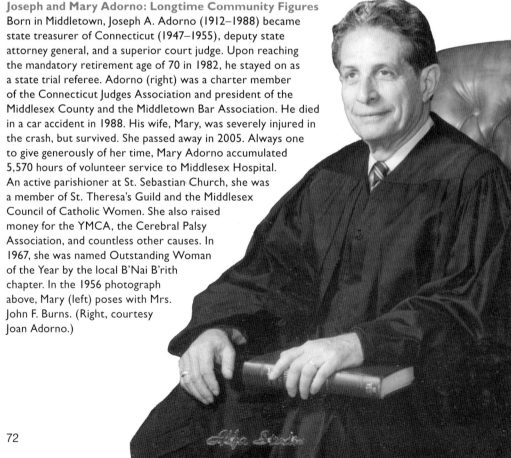

Edward B. Jackson:
Exemplary Police Captain
Born in Burlington, New Jersey, in 1915, Edward Jackson (pictured at center) became one of the longest-serving and most respected members of Middletown's police force, serving from 1951 through 1980. He was one of the first three African American officers to make rank in the department. Then, three years after retiring, he joined the Middlesex County Sheriff's Department and served as a captain until his death in 2000 at age 84. A member of AME Zion Church, Captain Jackson was buried in Indian Hill Cemetery. (Courtesy Middletown Police Department.)

Al Rasch: Westfield Fire Department Chief
When Al Rasch joined Middletown's Westfield Fire Department in 1939, the company was only eight years old. In 1972, he became the eighth chief of the department and served until 1977. In 1975, Chief Rasch was on the building committee that oversaw the construction of the new six-bay firehouse on East Street. Rasch also served his country in the South Pacific in World War II. He passed away in 2009.

Anthony Sbona: Legendary Mayor
A former football star at Middletown High School, Anthony "Buddy" Sbona became one of Middletown's most popular politicians. Moving from union carpenter to city councilman to three-term Republican mayor in a traditionally Democratic city, Sbona became a Middletown legend. After serving as mayor, he was town clerk for many years. Upon his death in 2003 at age 73, Carl Fortuna, a lifelong friend, said of Sbona, "His word was his bond. He had tremendous integrity." In the above photograph, four Middletown mayors gather for a portrait. They are, from left to right, Anthony "Tony" Marino, Kenneth Dooley, Michael Cubeta, and Buddy Sbona. The sign pictured at right marks the newly created street named after Sbona in 1990.

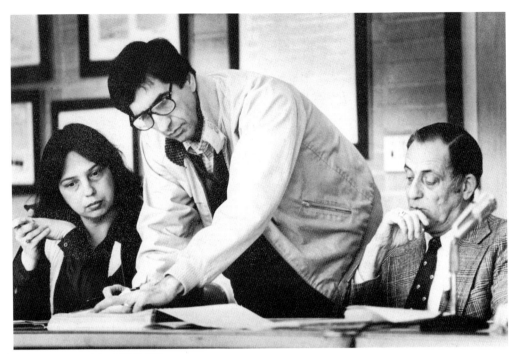

Sebastian Garafalo: Record-Setting Mayor

Born in 1932, Sebastian J. "Seb" Garafalo was a four-term Middletown mayor (1983–1989, 1991–1993). He served with the 169th Infantry in the Korean War and was a supporter of the Middletown Military Museum. He was also an active member of St. Sebastian Church, the Italian Society of Middletown, the Elks Lodge, the Polish National Home, and the Lions Club. His career included stints as tax collector, assistant to the mayor of East Hartford, and assistant to Second District congressman Rob Simmons. Garafalo passed away in 2004. Pictured from left to right are Mary Woods, Garafalo, and Jack Dunn.

Joseph P. Walsh: One of the Last High Sheriffs

Born in Middletown and a Navy veteran of World War II, Walsh served 27 years as high sheriff of Middlesex County. He also worked for 30 years as a jet engine tester at Hamilton Standard. Sheriff Walsh, at left in this photograph, passed away in 1999 at age 80. The office of high sheriff was abolished by a constitutional referendum in 2000.

Michael Cubeta: Popular Mayor

Following in the footsteps of his great-uncle, Salvatore Cubeta, who was Middletown's mayor from 1942 to 1946 and 1950 to 1951, Michael Cubeta served two terms as mayor of Middletown (1979–1983). When elected at age 28, he was the youngest mayor of a Connecticut city or town. His administration was known for action. He spearheaded the Aetna development, fiscal management initiatives, energy conservation measures, and government reorganization.

Maria Madsen Holzberg: First Woman Mayor of Middletown

In 1995, Maria Madsen Holzberg was elected the first woman mayor of Middletown. A graduate of Mount Holyoke College and the University of Connecticut School of Law, she served in the administrations of Governors Grasso and O'Neill. During her term, voters approved the construction of a police station on Main Street and the renovations of Snow School and the Wadsworth Mansion. After leaving office, she was appointed the first juvenile public defender for the Middlesex Judicial District. (Courtesy Maria Madsen Holzberg.)

Thomas J. Serra: Respected Educator and Community Leader
A lifelong resident of Middletown, Thomas Serra began teaching English at Vinal Technical High School in 1974. In almost 30 years at Vinal, he was a teacher, baseball and basketball coach, athletic coordinator, and principal. In addition, he has served his community as a member of many municipal committees and service organizations. In 1993, he was elected mayor of Middletown. Today, Tom Serra is majority leader of Middletown's Common Council.

Susan Bysiewicz: Connecticut Secretary of the State
Born in Middletown in 1961, Bysiewicz served the 100th Assembly District in the Connecticut State House of Representatives, representing parts of Middletown, Durham, and Middlefield. In 1998, Bysiewicz was elected secretary of the state, a position she held until 2011. Since 1835, only former governor Ella Grasso has matched Bysiewicz's 12-year-long time of service as secretary of the state. (Courtesy Susan Bysiewicz.)

George Dingwall: Law-Enforcement Hero
In 2000, a 19-year veteran of the Middletown Police Department, Sgt. George R. Dingwall, died in an automobile accident while pursuing suspected burglars. He was 47 years old. This photograph shows the memorial to Sergeant Dingwall at the Police Museum in the Middletown Police Headquarters building on Main Street. Charter Oak State College offers an annual scholarship in Sergeant Dingwall's name to full-time law enforcement officers. (Courtesy Middletown Police Department.)

CHAPTER FIVE

Military Heroes

The people of Middletown have given much to preserve their country and its freedoms. During the American Revolution, two Middletown men, Samuel Holden Parsons and Comfort Sage, served George Washington with distinction as trusted generals. Also in that war, Col. Return Jonathan Meigs Sr. led a famous raid on British forces on Long Island. During the War of 1812, Thomas Macdonough Jr.'s victory at the Battle of Lake Champlain is considered by many historians to be one of the most decisive battles in US naval history. In the Civil War, Thomas Holdup Stevens Jr. commanded many naval vessels, including the Navy's first ironclad warship, the *Monitor*. Also in the Civil War, Gen. Joseph K.F. Mansfield was mortally wounded by a Confederate bullet at the Battle of Antietam as he was leading his troops in battle on horseback. In World War II, an equally fearless general, Maurice Rose, was shot to death as he was personally leading an advance into Nazi Germany.

Sometimes, it is the stories of average GIs that are the saddest—for example, the death of two Middletown cousins named Sebastian Milardo. One was the first Middletown man to die in World War I, while the other was the first resident to die in World War II. The Middlesex County Historical Society safeguards a scrapbook that was kept by the second Milardo's mother. It holds training certificates and newspaper clippings of the young soldier's short career.

Another notable military personality showcased here is US military intelligence officer Max Corvo, who fought against the pro-Mussolini forces in Italy. More recent Middletown residents who have sacrificed for their country are Jerry Augustine, a veteran of the Vietnam War, and Tina Rickenback, who served in Operation Desert Storm. Since it is impossible in one chapter to mention by name the many Middletown men and women, living and dead, who served their country in uniform, these few will serve to remind readers of the sacrifices of thousands of Middletown people.

Comfort and Sarah Sage: Colonial Patriots

Beginning at the Battle of Lexington, when he marched his militia troops to Boston, Comfort Sage (1731–1799) served with the Colonial army during the first years of the Revolutionary War. Later, he was elected a representative to the Connecticut General Assembly and, in 1784, he became brigadier general of the 2nd Brigade. Comfort Sage's service also included being stationed with George Washington at Valley Forge. When Washington passed through Middletown in 1789, he visited Sage's home so he could see his old friend, who was ill at the time. The wife of Gen. Comfort Sage, Sarah Sage (1730–1799), is best known for the time she protected the two small sons of Benedict Arnold in her Cherry Street home. It was 1780, and the story of Arnold's traitorous acts was spreading through Connecticut. When a crowd of townspeople rioted in Middletown and hanged Arnold in effigy, Sarah made sure that the boys were protected from the mob and that they were not made aware of the reason for the violent protests. When her husband died on March 14, 1799, his body was laid out on his bed. Sarah Sage entered the room and lay down next to him. Sometime later, family members went into the room and found her dead. They believed that her death was caused by a broken heart. The Mortimer Cemetery mausoleum, pictured here, holds the remains of Comfort and Sarah.

Samuel Holden Parsons

An attorney practicing in Middletown before the Revolutionary War, Parsons (1737–1789) is credited with being the first Colonial leader to propose a Continental Congress of representatives of the American colonies. In 1775, Parsons was appointed colonel of the 6th Connecticut, a militia regiment. Leading it, he fought in the Battle of Bunker Hill. In August 1776, he was appointed brigadier general in the Army, with command of more than 2,500 troops. He worked to destroy the British fleet, fought at the Battle of White Plains, and planned fellow Middletown resident Return Jonathan Meigs Sr.'s Sag Harbor raid. In 1777, Parsons took charge of West Point and, in 1779, succeeded to Gen. Israel Putnam's command when a paralyzing stroke forced Putnam to resign. The following year, Parsons served on the board of officers that tried and sentenced to death Benedict Arnold's accomplice, British major John André. At the war's end, Parsons was promoted to major general and returned to Middletown, where he restarted his law practice and was elected to the state general assembly by the people of Middletown. Later, he moved to Ohio and was appointed first chief judge to the Northwest Territory. On November 17, 1789, Parsons's canoe capsized and he drowned in the rapids of Pennsylvania's Big Beaver River. Dying with him was a man with a broken leg whom it is believed Parsons was taking for medical treatment. Parsons's resting place is unknown, but this memorial stone was erected in Middletown's Mortimer Cemetery.

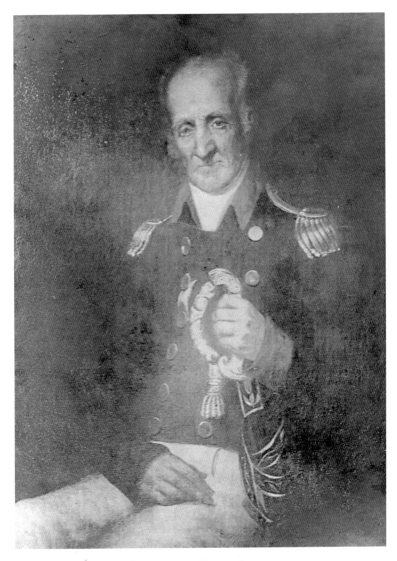

The Meigs: Military Leader and Postmaster General
Born in Middletown in 1740, Return Jonathan Meigs Sr. (shown here) was a colonel in the Continental Army during the American Revolution. Captured by the British in Benedict Arnold's invasion of Canada, he was paroled in 1776 and returned to Connecticut, where he continued his military service. The most famous of his subsequent exploits was his 1777 raid on the British forces stationed at Sag Harbor, Long Island. In that action, Meigs commanded 13 whaleboats with 220 men. Crossing Long Island Sound, they surprised the enemy at night, burned 12 British ships, and took 90 prisoners. No colonists were killed in the action. Later in life, Meigs was a founder of the Northwest Territory and a federal government Indian agent in Tennessee. Meigs's son, Return Jonathan Meigs Jr. (born in Middletown in 1764), was a teenager when his father was achieving fame as a Colonial leader in the Revolutionary War. In his early 20s, Return Jr. moved to Ohio, where he practiced law, became a territorial judge, and served as a legislator. After a short stint as chief justice of the Ohio Supreme Court, Meigs was elected US senator from Ohio. From 1810 to 1814, he served as governor of Ohio, and in 1814, he was appointed by Pres. James Madison to serve in his cabinet as the fifth postmaster general of the United States. James Monroe retained Meigs in the position until 1823. He passed away in 1825.

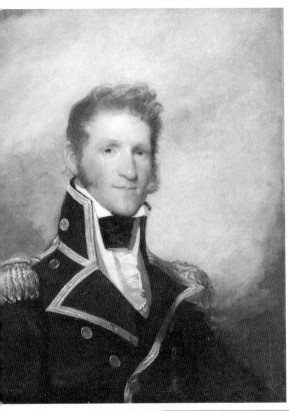

Thomas Macdonough: "The Hero of Lake Champlain"

A Middletown resident, Thomas Macdonough Jr. achieved fame for his part in the first Barbary Coast Wars and the War of 1812. He commanded the American naval forces that defeated the British navy at the Battle of Lake Champlain on September 11, 1814. It is considered by historians to be one of the most decisive battles in the history of the US Navy. During the more than two-hour-long battle, the British commander was killed and Macdonough was twice knocked unconscious. The battle gave the United States control of Lake Champlain and ended Britain's attempt to control the Great Lakes region. Macdonough died at sea in 1825 at age 41. His body was returned for burial in Middletown. The Middletown elementary school pictured below is named in his honor.

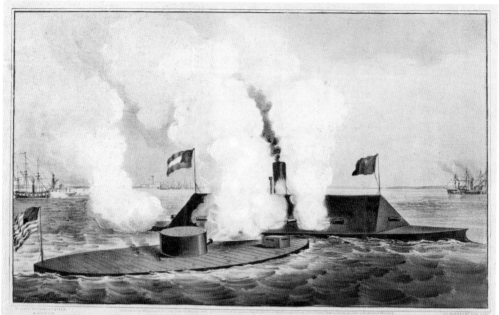

TERRIFIC COMBAT BETWEEN THE "MONITOR" 2 GUNS & "MERRIMAC" 10 GUNS.

Thomas Holdup Stevens Jr.: Civil War Navy Admiral

Stevens was born in 1819 in a house at the foot of Washington Street. His father was a US Navy commander who distinguished himself at the Battle of Lake Erie in the War of 1812. Thomas Stevens Jr. entered the US Naval Academy at age 17, did survey work in the Gulf of Mexico, was a naval storekeeper in Hawaii, and was promoted to lieutenant in 1849. During the Civil War, he commanded a series of vessels in several key engagements. He commanded the *Monitor*, the Navy's first ironclad warship, after its battle with the *Merrimac*. In 1864, Stevens, commanding the double-turreted *Winnebago*, led attacks on Confederate fortifications in the Battle of Mobile Bay. Stevens became a captain in 1866, a commodore in 1872, and a rear admiral in 1879. He commanded the Pacific Squadron in the year before he retired (1881). Admiral Stevens died in 1896 at age 76.

PIECE OF Armor of the Confederate Ram "Merrimac".

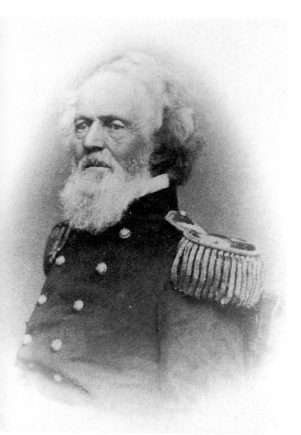
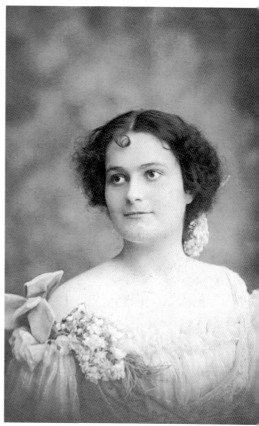

Joseph K.F. Mansfield: Martyred Civil War General

Born in 1803, Gen. Joseph K.F. Mansfield was a career US Army officer who made Middletown his home, both before and during the Civil War. In 1862, two days before the Battle of Antietam, he was given command of the XII Corps of the Army of the Potomac. At Antietam, known as the "bloodiest single-day battle in American history," Mansfield was shot in the chest by Confederate troops. He dismounted his horse, passed to the rear, and collapsed. Forming a chair with their muskets, five men picked him up and carried him to a place where he could be moved to a field hospital. He died the following morning. On the right is a photograph of General Mansfield's granddaughter Louisa M. Mansfield, who maintained the family home until she passed away in 1959. Soon afterward, the house was purchased by the Middlesex County Historical Society and opened as its headquarters.

Amster Dingle: African American Volunteer

Amster Dingle was born in Delaware about 1827 and married Emily Peters in 1855. They had three children, Elizabeth, Mary, and William. In 1863, they were living in Middletown when Dingle enlisted in Company F of the newly created African American regiment, the 29th Connecticut Volunteers. Only weeks later, Dingle died in camp in Fair Haven, Connecticut. He is buried in Mortimer Cemetery.

Elijah Gibbons: Antislavery Champion

Gibbons was a foreman at Benjamin Douglas's pump company. He lost his position as a sexton at First Baptist Church on Main Street when he chose to ring the bell at the moment abolitionist John Brown was executed. At the start of the Civil War, he raised a company of Middletown men who composed Company B of the 14th Connecticut Volunteers. He led this company through the September 1862 Battle of Antietam. At the Battle of Fredericksburg in December 1862, he was wounded in the thigh and died. Captain Gibbons is buried in Mortimer Cemetery.

86

George Hulse: Prisoner of War

Born in New York state around 1835, Middletown resident George Hulse worked as a sailor while his wife prepared oysters. When the Civil War began, he enlisted in Company A of the 2nd Connecticut Volunteers. Later, he joined Company I of the 99th New York Regiment. He was captured by Confederate forces and sent to the notorious Andersonville Prison Camp. In September 1864, he became one of the nearly 13,000 men who died there.

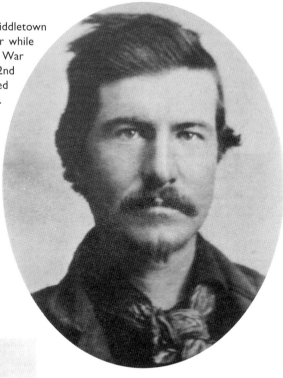

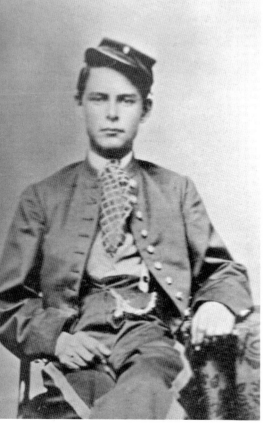

Dennis Deegan: Irish Soldier

Deegan was born in Middletown around 1846 to parents who emigrated from Ireland. In May 1863, Deegan joined Company G of the 9th Connecticut Volunteers as a drummer. The 9th was a regiment of men of Irish heritage that proudly proclaimed the motto "Destined to be Gallant" and sported a battle flag with an American eagle and an Irish harp. Deegan reenlisted in January 1864 and died six months later in camp of an unknown disease. He is buried in the cemetery behind St. John Catholic Church.

<div style="text-align:center">

MEMORIAL SERVICE

0800 — 6 September, 1942

U.S.S. MUGFORD

COMMANDER E. W. YOUNG, U. S. N.,
COMMANDING

LT. COMMANDER E. K. WAKEFIELD, U. S. N.
EXECUTIVE OFFICER

SERVICE CONDUCTED BY
LT. COMDR. F. T. BARKMAN, U. S. N. R.
CHAPLAIN

</div>

Sebastian Milardo: First to Die for Their Country

Cpl. Sebastian Milardo, 20, the son of Antonio Milardo of Ferry Street, died of meningitis while serving in France in World War I. He was the first Middletown death of the war. A member of Company C of the 1st Regiment, he had served at the Mexican border before being sent to Europe. Born in Melilli, Sicily, Milardo moved with his family to the United States when he was about five years old. The American Legion post in Middletown was named after Sebastian Milardo and another Middletown soldier, Miner Wilcox. A baby, Cpl. Milardo's first cousin, was born about four years after Milardo died and was named for him. That baby, the son of shoemaker Emmanuele Milardo of 21 Rome Avenue, grew up to serve as a machinist's mate in the US Navy. He was the first death of a Middletown serviceman reported in World War II. Like his cousin, he was 20 years old at the time of his death. This is a photograph of the program handed out at Corporal Milardo's memorial service on the USS *Mugford*.

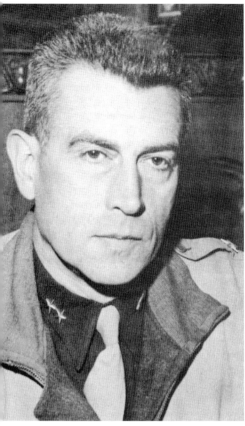

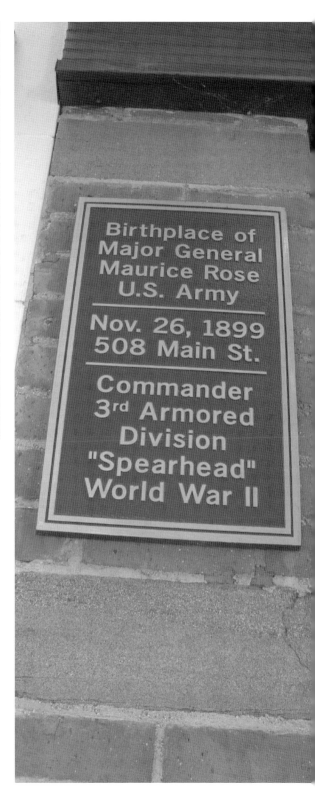

Birthplace of
Major General
Maurice Rose
U.S. Army

Nov. 26, 1899
508 Main St.

Commander
3rd Armored
Division
"Spearhead"
World War II

Maurice Rose: Major General
Middletown-born Maurice Rose was the commanding general of the US Army's 3rd Armored Division in World War II. The son and grandson of rabbis, he was the highest-ranking person of Jewish ancestry to serve in the US military during World War II. Andy Rooney, a war correspondent and later *60 Minutes* commentator, wrote that Rose "may have been the best tank commander of the war." On March 29, 1945, he led the 3rd Armored for 101 miles through Germany. It was the longest one-day advance through enemy territory in the history of warfare. General Rose died two days later at the hands of a German tank commander. He was the highest-ranking American military leader killed by enemy fire in Europe during the war. In 2010, the Middletown Army Reserve Center was named after General Rose. The local unit of the Jewish War Veterans bears his name. The plaque at right marks Rose's birthplace on Main Street in Middletown. (Above, courtesy Vic Damon.)

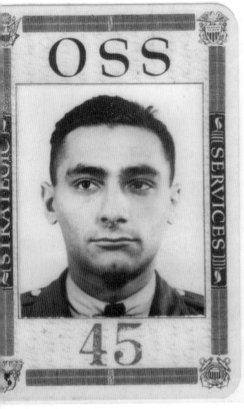

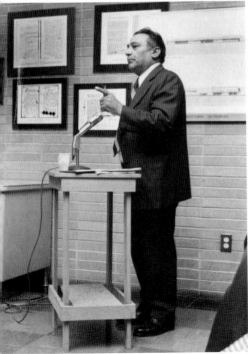

Max Corvo: Anti-Fascist Fighter
Coming to Middletown from Sicily at age nine, Biagio "Max" Corvo joined the US Army at age 22. During World War II, he worked in the Italian Secret Intelligence branch of the Office of Strategic Services to create plans that helped defeat the German and Italian fascist armies in Italy. His work included the delivery of supplies to anti-Mussolini partisans and the transportation of hundreds of Allied agents behind enemy lines. After Mussolini's death, Corvo worked at maintaining a relationship between Allied field commanders and Italy's new, democratic government. In later years, Corvo founded *The Middletown Bulletin*, which covered local news. He also worked as an international business consultant. He died at age 74 in 1994. (Courtesy William Corvo and the Max Corvo Archive at Trinity College.)

Jerry Augustine: Vietnam Veteran

Born in Middletown, Jerry Augustine was drafted into the Army in 1965 at age 19. He served in the 146th Light Infantry Brigade (1966–1967) and the 4th Infantry Division (1967). Above, he is pictured with Vietnamese children in 1967. From 1968 to 1975, he was a body builder, winning the Mr. New England and Mr. Northeast America titles. Early each year, the Empire State Building Run-Up is held in New York City in support of the Multiple Myeloma Research Consortium. Augustine has finished in first, second, or third place in his age division eight times. At age 54, Augustine placed 41st out of 210 competitors, racing up 86 floors (1,576 steps) in a little under 15 minutes. (Courtesy Jerry Augustine.)

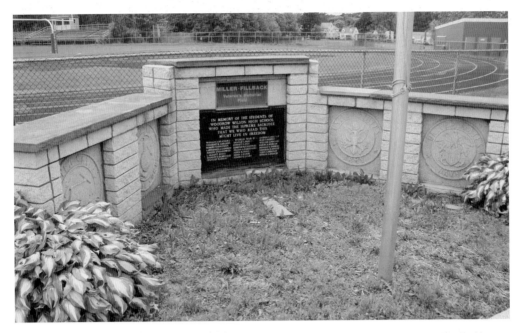

Woodrow Wilson High School Fallen Patriots
This monument at the Miller-Fillback Veteran's Memorial Field honors 23 Woodrow Wilson students who served in the Army, Coast Guard, Marines, and Navy in World War II and who died for their country. The monument was donated by Carl Morello and Sons in 1985.

Tina Rickenback: Operation Desert Storm Veteran
During Operation Desert Storm, Christina "Tina" Rickenback was called up to active duty and transported to Saudi Arabia, where she helped establish and served as head nurse of a ward in a 500-bed fleet hospital. After the war, she continued in the reserves, eventually becoming commanding officer of her own reserve unit. In 2003, she retired with the rank of captain after over 27 years of service. Today, she and her husband enjoy watching their grandchildren grow. In this photograph, Rickenback poses in her gas mask. (Courtesy Christina Rickenback.)

CHAPTER SIX

Unforgettable People

This chapter seeks to honor Middletown people who did not fit conveniently into other parts of this book. These individuals vary, from the Native American chief who saw his tribal lands overrun with new settlers, to a white man who wrote a book describing his time as a slave in North Africa—a book that had a major impact on young Abraham Lincoln's position on slavery.

Among those highlighted are a ship owner who transported fugitive slaves up the Connecticut River, Middletown civil rights leaders of the 1950s and 1960s, pioneering women physicians at Middletown's two hospitals, a brilliant scientist who spearheaded the development of vaccines for mumps and measles, a woman who shipped supplies to World War II–ravaged Great Britain, and an attorney who prosecuted war criminals at the end of that conflict.

Among the many Middletown residents who had to be left out because of page limitations are Christie McLeod, chief pathologist at Middlesex Memorial Hospital for 34 years; John Osborn, who was the first chemist in Connecticut and was responsible for introducing inoculations to the state; Capt. Sebastian Pagano Jr., a firefighter with the Middletown Fire Department for 28 years who died from a heart attack after returning from several runs with his company; and Idella W. Howell, who formed a nonprofit child development center for three- to five-year-olds.

This book could easily be filled with the dedicated residents who regularly support their community. For example, Jim Corbett and Marge Smith volunteer to assist students at, respectively, Bielefield and Moody Schools. At Middlesex Hospital, volunteers share their time and talents—to the amazing total of 80,000 hours annually. Some began in the 1940s, like Esther Kabatznik, Marion Newberg, and Margaret Gurland, who together provided an astounding total of 188 years and over 19,000 hours of volunteer service. Special tribute goes to Josephine Aresco, Bob Drouin, Catherine Zachary, and Linda Vecchitto, who collectively gave the hospital about 19,000 volunteer hours during their 64 years of service. Some currently active volunteers are Jackie McDowell, Mary Bartolotta, Joyce Swokla, and Elaine Parmenter, who continue to add to their combined service of 130 years. They will soon exceed 28,000 hours. Thousands of volunteers cannot be individually acknowledged in these pages. But they, too, gave of their time to make Middletown a better place to live. They, too, are unforgettable people!

Chief Sowheag and the
Mattabesetts and the Wangunks

The land on which Middletown sits was originally
territory of the Mattabesett Native American
tribe. In the 1640s, Sowheag was chief of both the
Mattabesetts, on the west side of the Connecticut
River, and the Wangunk tribe on both sides of the
river. In 1650, the first English families arrived in
Middletown from the Connecticut colony settlements
of Hartford, Wethersfield, and Windsor. Partly
because of the smallpox and yellow fever brought
by the Europeans, for which the native people had
no immunity, Chief Sowheag was forced to sell most
of the tribal lands to the colonial authorities. By the
late 1600s, the tribes were left with only about 300
acres on the east side of the Connecticut River and a
strip of land on the west side, which extended from
what is now Newfield to Indian Hill Cemetery. The
ponytail tomahawk pictured above was collected near
Middletown's Crystal Lake on land originally belonging
to the Mattabesetts. The 18th-century treaty on
the right is signed by local Native American leaders.
(Above, courtesy Margaret McCutcheon Faber.)

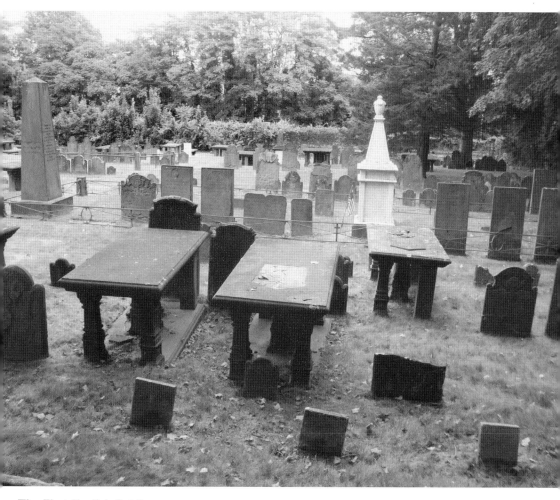

The First English Settlers

Many of the first English settlers of Middletown (also known as the Mattabesett District) are buried in Riverside Cemetery. Situated on a hill next to the Connecticut River, it was also a stone's throw from the first meetinghouse of the new settlement. Most of these settlers were young men and women who left Hartford to find a place where they could farm and build their first homes. A few, like 50-year-old George Hubbard, were hardened veterans. He had been one of the founders of Hartford 14 years before. In 1650, as he was leaving for Middletown, he was commissioned by the colonial government as "Indian Agent and Trader for the Mattabesett District." In 1666, he became keeper of the meetinghouse in Middletown. His eldest son, Joseph, was charged to beat the drum to assemble the congregation and to warn if Indians were seen approaching the settlement. Hubbard died in 1684 at age 83.

Nehemiah Hubbard: Deputy Quartermaster of the Continental Army

Born in Middletown in 1752, Hubbard was 21 years old when he signed on as a cargo owner's representative on a ship bound for the West Indies. He later became captain of the ship and a merchant. Early in 1776, he joined the Continental Army and was appointed a regimental paymaster. The following year, Maj. Gen. Nathanael Greene, quartermaster of the United States, made him deputy quartermaster for Connecticut. In that role, Hubbard played a key part in providing the Colonial troops with food, clothing, and supplies. After the war, Hubbard returned to Middletown, where he became one of the area's most successful merchants and the first president of the Middletown Bank. He died at age 85 in 1837. Shown at right is a signed portrait of Hubbard. Below is his home on Laurel Grove Road.

Martha Barnes: Community Inspiration

Martha Barnes was the subject of the 1834 biographical work *Memoir of Mrs. Martha Barnes, Late of Middletown, Connecticut*. It was written the year she passed away by John Cookson, pastor of Middletown's First Baptist Church. Born in Middletown in 1739, Barnes married Jabez Barnes at age 18. Years later, when he died on a voyage to the West Indies, Martha was left with eight children to raise alone. Even though she barely made a living with her husband's tiny farm and her part-time work at weaving, Martha was known for her charity. Once, when the Baptist church needed windows, parishioners complained that they had given all they could afford. Then, Barnes gave her last dollar, money that had been earmarked for butter and sugar. Seeing this, one man remarked, "If Mother Barnes can give a dollar, I can give five dollars." Others followed suit, and before long, enough funds were raised to pay for the windows. Barnes lived to age 95. The drawing shown here was one of a series of sketches made during the last year of her life by her grandson.

Nathan Starr Jr.: Arms Manufacturer

The oldest son of Nathan and Polly Starr, Nathan Starr Jr. (1784–1852) was a manufacturer of guns and swords in Middletown in the first half of the 19th century. Between 1815 and 1845, the Starr family's company manufactured 1,000 rifles, 19,000 muskets, 3,000 cutlasses, 22,150 cavalry sabers, and 5,180 swords. Later, his son Ebenezer Starr would produce the third most-widely used revolver in the Civil War.

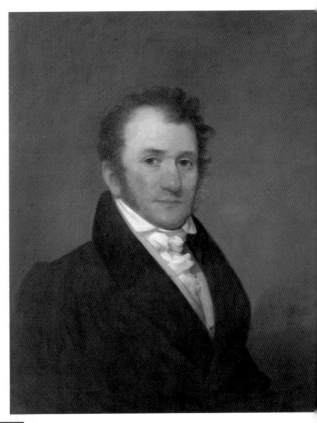

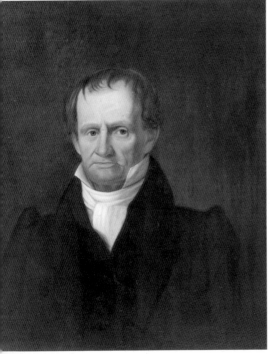

Joshua Stow: Champion of Religious Liberty

In 1762, Joshua Stow was born in Middlefield, when it was still a part of Middletown. In his 30s, Stow helped to survey the Western Reserve, an area of present-day Ohio that was owned by the State of Connecticut. In Middletown, he became a postmaster, tax collector, and judge. He is perhaps best known for his role at Connecticut's Constitutional Convention in 1818, where he successfully led the effort to eliminate the requirement that a person needed to be a member of the Congregational Church to hold public office in Connecticut.

NARRATIVE, &c.

CHAPTER I.

A brief Sketch of the Author's Life and Education, up to the month of May, 1815.

WAS born in the town of Middletown, in the State of Connecticut, on the 27th of October, in the year 1777, during the war between England and America, which terminated in 1783, with the acknowledgment by the mother country of the freedom, sovereignty, and independence of the thirteen United States. My father, Asher Riley, who still lives in the same place, was bred to the farming business, and at an early age married my mother, Rebecca Sage, who is also yet living. I was their fourth child. Owing to an attack of that dangerous disorder, the liver complaint, my father was rendered incapable of attending to his usual employment for several years, during which time, his property, very small at first, was entirely expended; but after his recovery, in 1786, he was enabled, by industry and strict economy, to support his increasing family in a decent manner.

It may not be improper here, before I speak of my education, to give a general idea of what was then termed a common education in Connecticut. This state is divided into counties and towns, and the towns into societies; in each of which societies, the inhabitants, by common consent, and at their common expense, erect a school-house in which to educate their children. If the society is too large for only one school, it is again subdivided into districts, and

B

James Riley: The Writer Who Influenced Lincoln

Born in 1777 in the Upper Houses section of Middletown, now called Cromwell, James Riley spent his boyhood as a manual laborer on local farms. Hoping for something better, at age 15, he left Middletown for a life at sea. Progressing through the ranks of cabin boy, cook, seaman, second mate, and chief mate, by the age of 20, he was given command of his own ship. Later, Riley became captain of the US merchant ship *Commerce*, which in 1815 was shipwrecked off the western coast of North Africa. He and his men were captured by a local tribe, beaten, forced to drink their own urine, and worked almost to death. After escaping, they returned to America. Riley wrote the book *Authentic Narrative of the Loss of the American Brig Commerce*, later republished as *Sufferings in Africa*. It sold more than a million copies in the United States and helped to demonstrate the evils of slavery to white Americans. Captain Riley moved to Ohio, where he became a member of the legislature and devoted himself to the abolition of slavery in the United States. Later, he returned to the sea and died aboard ship in 1840. Pres. Abraham Lincoln once said that *Sufferings in Africa* influenced him more than any other book except the Bible and *Pilgrim's Progress*. Portions of Riley's family house still stand on the grounds of Holy Apostles College & Seminary in the town of Cromwell. Shown here is a page of an early 19th-century edition of Riley's book. (Courtesy Russell Library.)

Fanny Johnson: Ancient Charitable Society

In 1811, Fanny Johnson (1779–1851) became the first secretary of the Middletown Female Charitable Society. Believed to be the second-oldest incorporated charitable society in the United States, it is still helping needy people of Middletown with a modest endowment providing about $5,000 each year. Over the centuries, it has provided relief for hundreds of small needs not met by other organizations and agencies. This c. 1800 pastel portrait has been attributed to artist James Sharples (1751–1811).

Frances Russell: Library Benefactor

In 1875, Frances Russell, the widow of wealthy trader Samuel Russell, purchased the 40-year-old building at the corner of Broad and Court Streets that housed the Episcopal Christ Church. The parish was moving to a new church building on Main Street. Russell remodeled the old building and it was dedicated as the City of Middletown's public library on November 17, 1875.

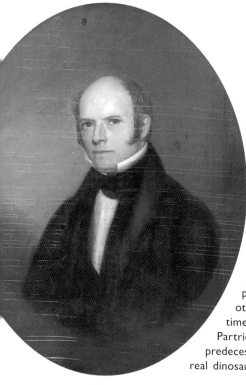

Joseph Barrett: Dinosaur Tracks

Born in England in 1798, Barrett came to the United States at age 25. Graduating from Yale College with a medical degree in 1834, he embarked on a career as a doctor. This was cut short when he devoted nearly all his time to his hobby: the search for bird tracks and fossils in the lower Connecticut River valley. Although his work became obsessive, his collection of paleontological pieces and Native American artifacts proved to be valuable additions to many museums and other institutions, including Wesleyan University. At one time, he was professor of botany and mineralogy at Captain Partridge's Literary, Scientific, and Military Academy, the predecessor of Wesleyan University. A brownstone slab with real dinosaur footprints on its back serves as his grave marker.

Jesse G. Baldwin: Antislavery Society Founder

The Underground Railroad was a network of secret routes traveled by fugitive African American slaves to reach Canada and the free states. One of the people who assisted as a conductor and station keeper in Connecticut was Jesse G. Baldwin (1804–1887), who lived at 15 Broad Street in Middletown. As a young man, Baldwin had seen slavery firsthand when he traveled through the Southern states as a peddler. In 1833, at age 29, he settled in Middletown, established a general store, became a ship builder, and cofounded the city's antislavery society. His ships the *W.B. Douglas* and the *Jesse G. Baldwin* transported fugitive slaves up the Connecticut River. In Middletown, slaves would often be sheltered at Baldwin's home until he could arrange wagon transportation for them to Underground Railroad stops in Hartford or Farmington. Jesse Baldwin lived until 22 years after the Civil War freed all US slaves, dying at age 83. He is buried with his wife, Lydia, in Middletown's Indian Hill Cemetery.

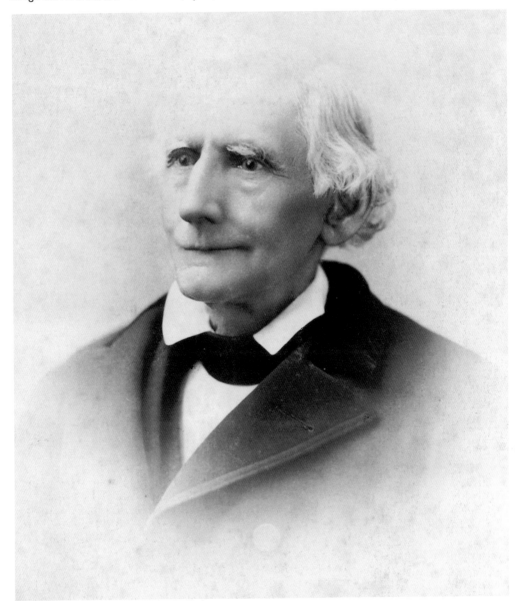

Wilbur Olin Atwater: Health Pioneer

Atwater (1844–1907) was noted for his pioneering work on human metabolism and nutrition. He graduated from Wesleyan in Middletown and obtained his doctorate at Yale. In 1873, he became professor of chemistry at Wesleyan University and, two years later, was appointed the first director of the United States Experiment Station at Wesleyan. His caloric tables are still used worldwide, and his studies impacted national health policies. (Courtesy Wesleyan University.)

Frank Farnsworth Starr: Middletown's Premier Genealogist

Son of Gen. Elihu W.N. Starr and Harriet Wetmore Bush Starr, Frank Farnsworth Starr (1852–1939) was a professional genealogist in Middletown for 70 years. Accumulating over 3,500 pages of genealogical research, he also took it upon himself to handwrite 11,000 gravestone inscriptions from cemeteries in Middletown and surrounding towns. He lived his entire life at the family home on Mount Vernon Street. Upon his death, he bequeathed his files to the Middlesex County Historical Society.

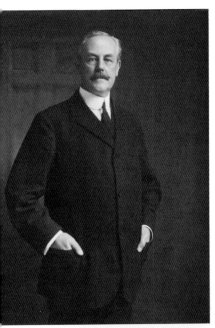

Edward Campion Acheson: Episcopal Bishop

Born in England in 1857, Edward Acheson immigrated alone to Canada. In 1892, he married Eleanor Gertrude Gooderham (1870–1958), granddaughter of a successful Canadian distiller. After less than a year as rector in New York City, Acheson and his young wife moved to Middletown. In 1915, he became Episcopal bishop of Connecticut. Acheson died in 1934, a year after his son, Dean Gooderham Acheson, became a US undersecretary of the treasury and 15 years before Dean would become the US secretary of state.

Clarence Wadsworth: The Colonel of Wadsworth Street

Perhaps best known today as the builder of the Wadsworth Mansion (shown here), Clarence Wadsworth was a colonel in the 12th Regiment of the New York National Guard and took part in General Pershing's punitive expedition against Pancho Villa in 1916. For several years after that, he was a captain in Connecticut's Governor's Foot Guard. The founder of the Rockfall Corporation, Wadsworth was a philanthropist and conservationist. He died in 1941.

Francesco Lentini: The Boy with Three Legs

Born with three legs and a foot growing from the third leg, Francesco Lentini moved from Sicily to Middletown and toured with the Barnum & Bailey Circus, Buffalo Bill's Wild West Show, and many other circuses and carnivals. The extra leg and foot were part of two siblings who never fully developed. When young, Lentini visited an institution housing blind and badly crippled children and saw, in his words, that his "lot wasn't so bad after all." Years later, when asked about his extra leg, Lentini said, "No, my limb does not bother me in the least. I can get about just as well and with the same ease as any normal person—walk, run, jump; ride a bicycle, horse; ice and roller skate; and drive my own car. I can swim—one advantage I have over the other fellow when I swim is that I use the extra limb as a rudder." Lentini married, fathered three sons and a daughter, and died in his 80s in Florida in 1966. During his early years, Lentini was managed by fellow Sicilian Vincenzo Magnano, who was the second person of many hundreds to settle in Middletown from Melilli, Sicily. (His brother Angelo was the first, in about 1886.) After going on circus tours with Lentini, Magnano settled in Middletown and owned a grocery store on Center Street.

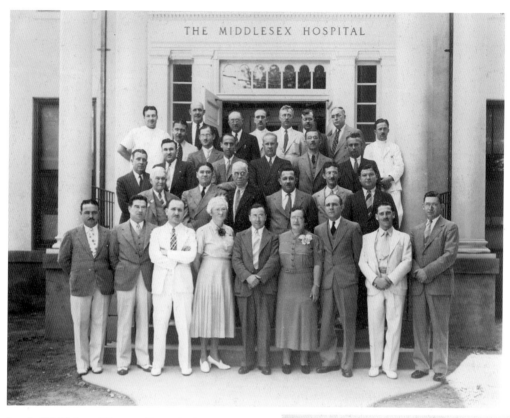

THE MIDDLESEX HOSPITAL

Jessie W. Fisher: Pioneer Female Doctor

Dr. Jessie W. Fisher, a pathologist at the Connecticut Hospital for the Insane, was one of the few women practicing medicine in Middletown in the early 1900s. In the above photograph, she is in the first row, fourth from left. In 1902, she was paid $116.67 per month. In 1916, Dr. Fisher accepted a position as a pathologist at Middlesex Hospital. In her position as director of the Middletown Department of Health Laboratory, Dr. Fisher prepared monthly laboratory reports. The one pictured at right, from November 1923, shows that 289 examinations were performed for diphtheria, malaria, typhoid, and other diseases. (Right, courtesy Russell Library.)

HEALTH COMMITTEE
MAYOR
HEALTH AND NUISANCE COMMITTEE OF COUNCIL
TOWN BOARD OF SELECTMEN
THOMAS F. WALSH, M. D., HEALTH OFFICER
A. M. McHUGH, D. V. S., MILK INSPECTOR

JESSIE W. FIS

MIDDLETOWN DEPARTMENT OF HEALTH
LABORATORY

MIDDLETOWN, CONN. November 19

LABORATORY REPORT

Total examinations	289
First culture examined, Diphtheria	41
Blood examinations for Malaria	66
Blood examinations for Para A & B-	18
Typhoid;	
Widal	9
Urine	12
Feces	3
Positive Widals	3
Positive Urines	3
Sputum examinations for tuberculosis	16
Positive sputum examinations	2
Smears for Gonorrhoea	16
Wasserman blood tests	71
Positive Wassermans	7
Milk specimens examined	37

Jessie W. Fish

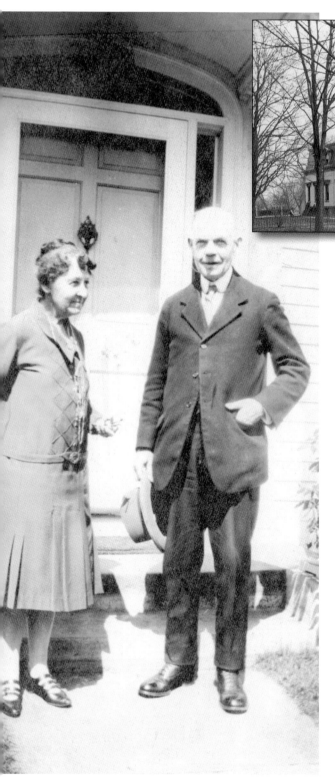

Kate Campbell Hurd Mead: Medical Doctor and Writer

Born in Canada, Kate Campbell Hurd Mead was a respected physician and the author of *A History of Women in Medicine*. She was one of the founders of Middlesex Hospital (above) and was instrumental in the founding of the Middletown District Nurses Association. Hurd Mead started her medical practice in Middletown in 1903 and served as a consulting gynecologist at Middlesex Hospital from 1907 to 1925. She was vice president of the State Medical Society (1913) and president of the Middlesex County Medical Association (1916). From 1925 to 1929, she traveled to Europe to do research on the history of women in medicine. Upon her return to the United States, she opened a practice in Haddam. In 1941, Dr. Hurd Mead ran to the aid of a friend who had collapsed while attempting to put out a grass fire. Both died. Hurd Mead was 73. She is seen at left with her husband of 51 years, Wesleyan English professor William Edward Mead. He passed away eight years after his wife's death, at age 88.

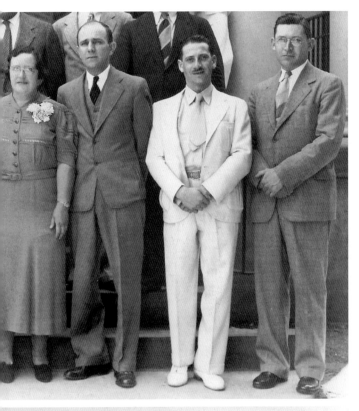

Ella A. Wilder: Middlesex Hospital's Chief Anesthetist
A graduate of Boston University School of Medicine in 1923, Dr. Ella Wilder moved to Middletown in 1925. She was chief anesthetist at Middlesex Hospital from 1927 through 1935 and an obstetrician from 1934 until her death. She was also the physician for Long Lane School for almost 20 years. At times, Wilder was vice president of both the Middlesex County and Central Medical Societies. She passed away in 1949 at age 52. From left to right are Dr. Wilder, Dr. Stephen H. Fekety, Dr. Soreffi, and Dr. Harold E. Speight.

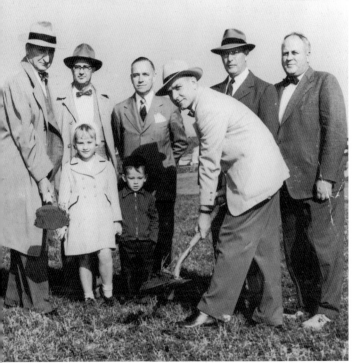

Theodore Raczka: Prosecutor of War Criminals
The son of Polish immigrants, Theodore "Ted" Raczka was a Middletown attorney for 59 years. During World War II, Raczka served in the Judge Advocate General Corps and aided in the prosecution of Japanese war criminals at the end of the war. A strong proponent of education, he served on the Middletown School Board for 20 years. In this photograph, Raczka is using a shovel to break ground for Bielefield School, while his two children, Cathy and Ted, watch. Raczka passed away in 2000 at age 82. (Courtesy Theodore V. Raczka.)

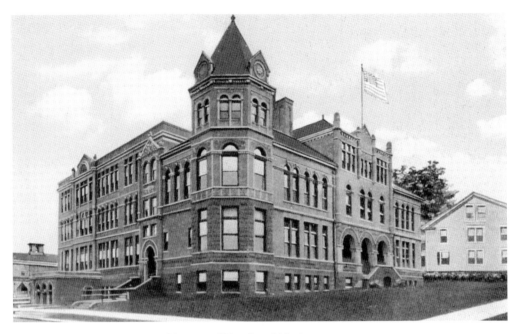

Janet Huntington Brewster Murrow: Wartime Worker

Janet Huntington Brewster was born in Middletown in 1910 and graduated from Middletown High School. She married future broadcast journalist Edward R. Murrow in 1934. While they were living in London, Janet became a leader of Bundles for Britain, an American women's organization that gathered and shipped supplies to war-ravaged Great Britain. During the war, she made radio broadcasts for the BBC and wrote or edited many of her husband's scripts. Brewster passed away in 1998. This photograph shows Middletown High School at the time of Brewster's graduation.

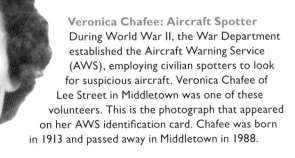

Veronica Chafee: Aircraft Spotter

During World War II, the War Department established the Aircraft Warning Service (AWS), employing civilian spotters to look for suspicious aircraft. Veronica Chafee of Lee Street in Middletown was one of these volunteers. This is the photograph that appeared on her AWS identification card. Chafee was born in 1913 and passed away in Middletown in 1988.

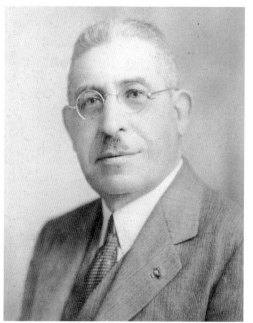

Leo B. Santangelo: Barber to Mayor
Santangelo was born in Melilli, Sicily, and almost did not make it to America. The ship that was transporting him across the Atlantic Ocean was delayed by severe storms and used up all of its fuel. The crew had to burn every combustible item on board to make it across the Atlantic. First working as a barber, Santangelo moved into real estate and insurance. He was elected mayor of Middletown in 1934, becoming the first Italian mayor of the city. He died at age 74 in 1944. (Courtesy The City of Middletown Mayor's Office.)

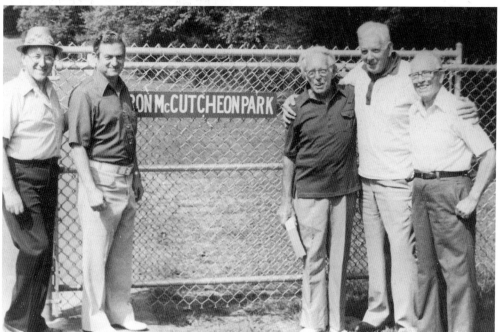

Ernest McCutcheon: Insurance Executive
A graduate of Middletown High School and a World War I Navy veteran, Ernest McCutcheon was hired by the Aetna Life & Casualty Company. After years as an Aetna agent, he founded McCutcheon Burr & Sons, one of Middletown's most successful businesses. This photograph was taken at the September 3, 1979, dedication of Ron McCutcheon Park. From left to right are Joe Lombardo, Tony Marino, Ron M. McCutcheon, Bernie O'Rourke, and Ernest McCutcheon. (Courtesy Ronald W. and Lois McCutcheon.)

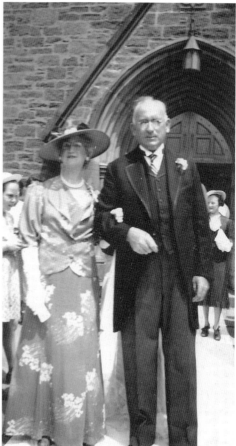

Pat Kidney: A Life of Public Service

Born in 1887, Pat Kidney married, had four children, and ran a barbershop near the corner of Washington and Main Streets. In his late 30s, he decided to devote the rest of his life to public service. He became Middletown's superintendent of parks and playgrounds, a truant officer, a probation officer, and the field director for the Connecticut Humane Society. During Kidney's time running the parks department, the city went from having only three parks and playgrounds to a total of twelve. It has been said that during the 1930s and 1940s, Kidney was probably the best-known person in Middletown and quite possibly the most respected. When Kidney retired in 1947 after 33 years of service, his four positions were filled by four different people. The left photograph shows Kidney holding the hand of his grandson, Phil Pessoni, in 1941. On the right, Kidney and his wife, Rose, are standing in 1936 in front of St. John Roman Catholic Church at the north end of Main Street. Pat Kidney passed away in 1967 at age 90. (Courtesy Phil Pessoni.)

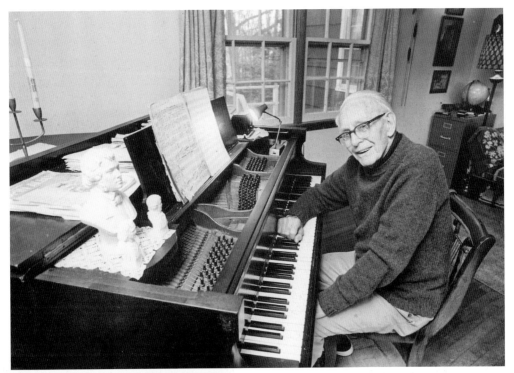

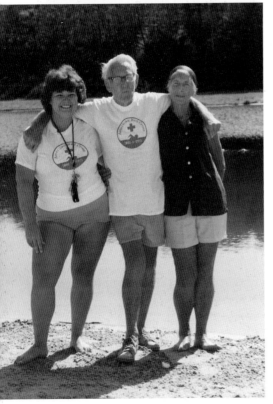

Ronald McCutcheon: Musician, Lifeguard
A World War I veteran, Ronald M. McCutcheon
was a lifelong musician, composer, and music
teacher. He was a Yale music school alumnus and
a graduate of the New England Conservatory of
Music in Boston. In addition, McCutcheon was an
amateur archeologist and an explorer of the native
cultures of the Americas. In a parallel career of
over 60 years, he served Middletown as a lifeguard
and swimming instructor, teaching thousands
of children to swim at Crystal Lake, Pameacha
Pond, and Falcon Park. When he was in his 80s,
McCutcheon was considered by many to be the
oldest lifeguard in the United States. When he was
89 years old, Middletown mayor Sebastian Garafalo
declared September 17, 1986, to be Ronald M.
McCutcheon Day. In his proclamation, the mayor
stated that McCutcheon lives by his belief, "Keep
Busy. Go forward, and do the best you can!"
(Courtesy Ronald W. and Lois McCutcheon.)

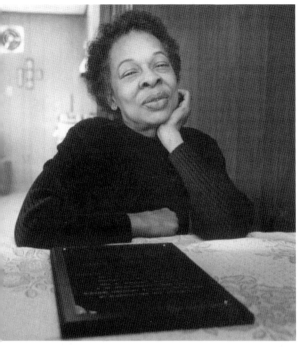

Lillian Moses: Health-Care Leader
The daughter of a South Carolina sharecropper, Lillian "Reba" Moses and her husband, James, came to Middletown in the 1940s. They helped build Zion Church and, in 1972, Reba Moses became one of the three main founders and an original board member of the Community Health Center (CHC), a free clinic. Starting in a walk-up apartment, it has since become one of the major health-care providers in Connecticut, with over 130,000 patients. At the time of Moses's death in 2012 at age 88, fellow CHC founder Mark Masselli stated, "She was a foot soldier in the civil rights movement and the war on poverty. . . . She was not afraid to speak the truth to power. She would stand up for any injustice she saw." Below is a 1985 photograph of the CHC's Long Range Planning Committee. Moses is seated in the center. (Courtesy Mark Masselli.)

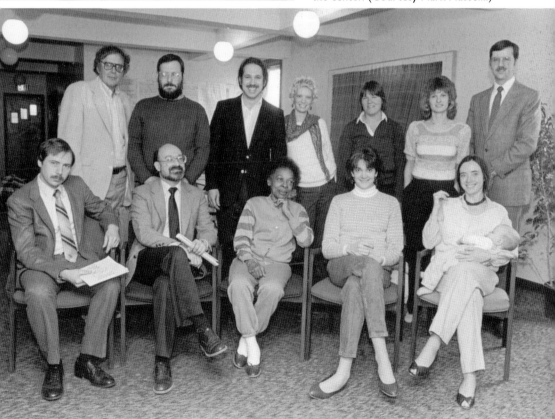

Nathan Shapiro: Businessman and Community Volunteer

Nathan Shapiro was the owner and manager of Shapiro's Inc., one of the most popular department stores in Middlesex County. During World War II, he served in the US Army as a medic for over three years and helped in the liberation of German concentration camps. After Shapiro's store was sold in 1986, Nathan Shapiro devoted countless hours to service to the community in such positions as municipal agent for the elderly in Middletown and as a volunteer at Middlesex Memorial Hospital. He died in 2004 at age 87. (Courtesy the Shapiro family.)

Bernie O'Rourke: Middletown Legend

Restaurant owner, Middletown's city parks and recreation director, sports editor for the *Middletown Press*, and a legend in Middletown, Bernie O'Rourke was responsible for bringing Little League baseball to Connecticut. Bernie O'Rourke Drive near Palmer Field is named for him. After O'Rourke died in 1986, his restaurant was taken over by his son Brian, who carried on his father's tradition of caring for his neighbors.

Guy A. Settipane: Medical Journal Founder
After Middletown-born Guy Settipane served in the US Navy (1957 to 1962), he began a 42-year career as a doctor in the fields of allergy and immunology. A full clinical professor of medicine at Brown University, he founded the Allergy and Asthma Center in Providence, Rhode Island, and authored six medical textbooks. He was known internationally for his founding of Ocean Side Publications and his work as co-editor-in-chief of *Allergy & Asthma Proceedings*. Settipane died in 2004 at age 74. (Courtesy Russell Settipane.)

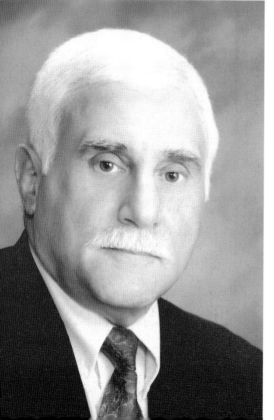

Philip Cacciola:
American Legion Commander
Cacciola's athletic accomplishments are many: outstanding performance on Middletown High School football and baseball teams (1955–1959), co-captain of the Norwich University football team, Wesleyan University assistant line coach, and Middletown High assistant softball coach. He is also a retired US Army colonel and was head of consumer protection for Middletown. Today, Cacciola serves as a member of the board of directors of the Sports Hall of Fame and is the commander of American Legion Post 75. (Courtesy Middletown Sports Hall of Fame.)

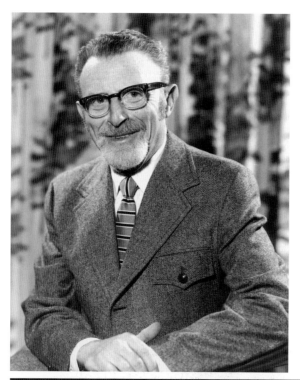

Max Tishler: Renowned Chemist

After earning a PhD in chemistry from Harvard University in 1934, Max Tishler began 32 years with Merck & Co., the world's largest prescription drug company. He was responsible for developing commercial production of vitamins B12, C, B6, D, E, and K1, and he led Merck's development of measles, mumps, and German measles vaccines. Because of Tishler's work, Merck was able to mass-produce penicillin during World War II. While working at Merck, he received more than 100 patents in the areas of medicinal chemicals, vitamins, and hormones. After retiring as senior vice president of research and development, Dr. Tishler joined Wesleyan University, where he served for 17 years (1970–1987) as a professor of chemistry. He died in 1989 at age 82. Below, Tishler (right) poses with fellow world-renowned chemist Linus Pauling. (Courtesy Wesleyan University.)

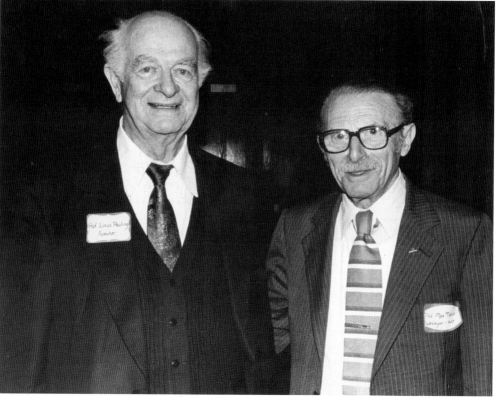

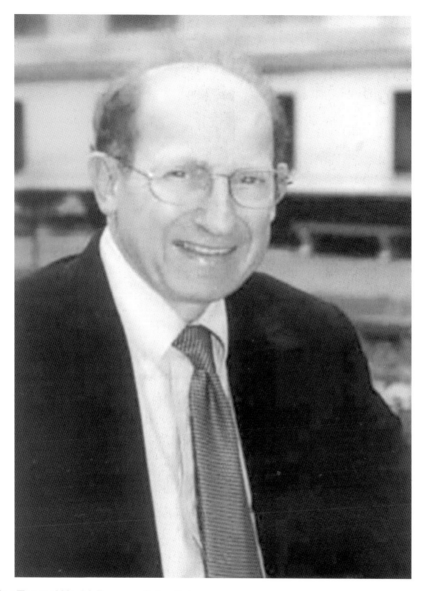

Nicholas Turro: World-Famous Scientist

One of the most respected organic photochemists in the world, Nicholas Turro was born in Middletown in 1938 to second-generation Italian Americans. He attended St. John's School, Middletown High School, and Wesleyan University. In 1963, he received his PhD from the California Institute of Technology (Caltech) and went on to do postdoctoral research at Harvard University. For 48 years, to the time of his death, Turro taught at Columbia University, in positions that included professor of chemistry, professor of chemical engineering and applied science, and professor of earth and environmental engineering. During his long career, Turro published 990 peer-reviewed research papers and wrote influential textbooks, including *Molecular Photochemistry*, which is often referred to as the bible of the field of organic photochemistry. At his death in 2012, Turro's friend and colleague at Caltech, Prof. Harry Gray, stated that Turro was "a truly spectacular teacher-scholar who made everyone he worked with better," and, as "a scientist who loved people, Nick devoted enormous amounts of time and energy to training students of all ages." (Courtesy Alessandro J. Fernandez.)

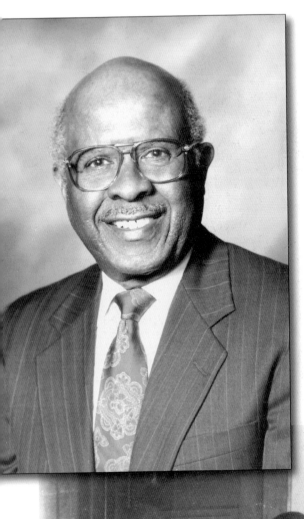

Willard McRae: Preeminent Community Leader

A longtime community leader, Willard McRae has impacted many by being a positive role model and an advocate for quality of life in education, health, and human services. He served as chairman of the Liberty Bank board of directors and has been active with the Middlesex County Community Foundation, the Middlesex Coalition for Children (he was a cofounder), and Wesleyan University's Upward Bound program. Also, McRae was administrative director of the Middlesex Hospital Mental Health Clinic. The Willard M. McRae Community Diversity Award is presented annually by Liberty Bank to a nominee who demonstrates leadership and community involvement and fosters positive relationships among people. The photograph below shows a young Willard McRae (center) with his brother Irving and sister Vivian at their Union Street home.

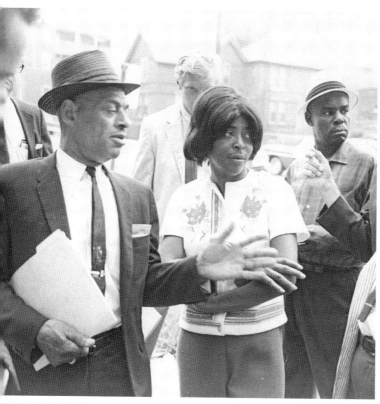

William Davage: Civil Rights Advocate
Born in Roselle, New Jersey, Rev. William Davage moved to Middletown in 1948 and became pastor of the Cross Street African Methodist Episcopal Zion church, serving until 1953. He then served as Middletown's welfare investigator and became one of the city's most outspoken civil rights advocates. In the 1970s, he was appointed Middletown's first human relations director. Rev. Davage, seen here holding a folder, passed away in 1975.

Bernie Fields: Jeweler and Philanthropist
After 59 years serving Middletown as a jewelry store, Bernie Fields Jewelers closed in 2009. Originally known as Pinsker's Jewelers, new owner Bernie Fields gave it his name in 1950. Marty Fields, Bernie's son, worked there for 50 years. Both Marty and Alan Fields, Bernie's grandson, ran the business after Bernie's death in 1998. Bernie Fields was known as one of the biggest supporters of the Big Brothers and Big Sisters organization as well as of local sports teams. Bernie Fields appears at the left in this photograph.

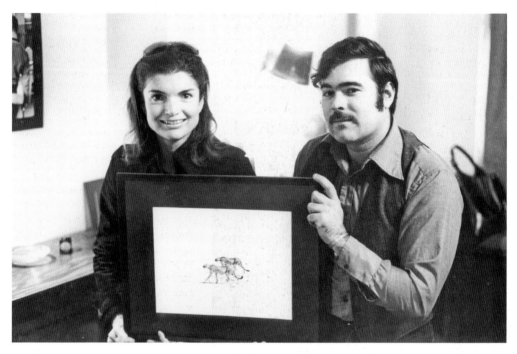

Phil Pessoni: New York City Photo Lab Owner

Pessoni was born in Middletown and attended Central School and Middletown High School. After graduating from Wesleyan University, he started Lexington Photo Labs in New York City in 1964. In 1970, writer and photographer Peter Beard was dating Jacqueline Kennedy Onassis' sister, Lee Radziwill, and spent most of the summer on the Onassis island Skorpios, and his yacht *Christina*. Jackie needed someone she could trust to process her family film and pictures, and Peter recommended Lexington Labs. That began a close friendship between Phil Pessoni and Jackie Onassis that lasted until her death in 1994. Pessoni still corresponds with Caroline Kennedy. The photograph above shows Onassis and Pessoni in 1970 with Beard's photograph "Walking Cheetahs." Below, Caroline Kennedy and Pessoni are seen at her photograph exhibit at Pessoni's gallery in 1975. (Courtesy Phil Pessoni.)

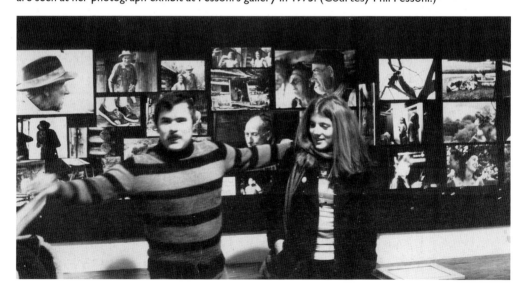

Lawrence McHugh: Chamber of Commerce Legend

Lawrence "Larry" McHugh has served as president of the Middlesex County Chamber of Commerce since 1983. A 1962 graduate of Southern Connecticut State College (now Southern Connecticut State University), he also worked as a successful football and track coach for more than 20 years. Under McHugh's leadership, the chamber of commerce's active membership has grown from 282 to more than 2,500. In 2009, McHugh was named chairman of the board of trustees of the University of Connecticut. At his appointment, Connecticut governor M. Jodi Rell stated, "Larry McHugh has been a legendary—and legendarily successful—educator, business leader, and community leader in our state for decades." Below, McHugh is pictured with the University of Connecticut women's basketball team as they are received by President Obama at the White House. (Courtesy Middlesex County Chamber of Commerce.)

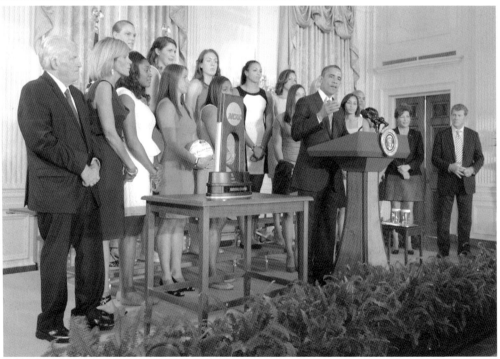

Memorial to Victims of 2010 Explosion

On February 7, 2010, six workers lost their lives in an accident on the construction site for Kleen Energy Power Plant on River Road in Middletown. The victims were Peter C. Chepulis, Ronald J. Crabb, Raymond E. Dobratz, Kenneth W. Haskell Jr., Roy D. Rushton, and Vance C. Walters. The explosion, which was heard more than 40 miles away, occurred during the cleaning of debris from natural gas pipes.

Anong and Andrew Becker: Power Couple

Anong Dangphim Becker was a Buddhist woman who met her future husband, Jewish American soldier Andrew Becker, during the Vietnam War. In 1970, they were married in Anong's native Thailand. When they returned to the United States, Andrew landed a position with a law firm, and Anong opened the Thai Gardens restaurant, at the corner of College and Main Streets. Although she closed the establishment in 2000, Anong later opened another restaurant on Main Street, Eleanor Rigby's steak house. (Courtesy Andrew and Anong Becker.)

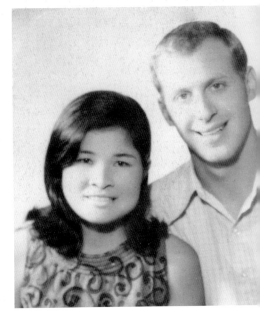

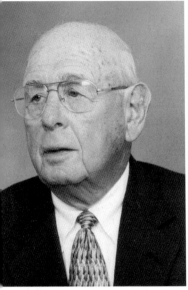

Buzzy Levin: Top Sponsor

Jerome "Buzzy" Levin, the longtime owner of Malloves Jewelers, was a key figure in Middletown baseball for well over half a century. After playing ball at Middletown High School, Levin played for the semiprofessional Middletown Giants for 10 years. In 1948, he helped found Little League baseball in Middletown and served as Little League district director for 32 years. From 1980 to 1993, he sponsored a team in the Greater Hartford Twilight League. (Courtesy Buzzy Levin.)

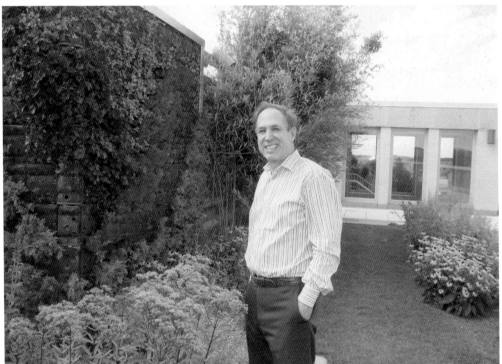

Mark Masselli: Community Health Center Founder

In 1972, Mark Masselli, Reba Moses, and Jerry Weitzman teamed up with several Wesleyan University students and community activists to found the Community Health Center (CHC) as a free clinic. With the motto "Health Care is a Right, Not a Privilege," Masselli has helped CHC grow to include over 200 service locations across Connecticut and more than 130,000 patients. Over the years, he has also helped found and support the New Horizons Battered Women's Shelter, the Nehemiah Housing Corporation, and other groups that help the people of Middletown.

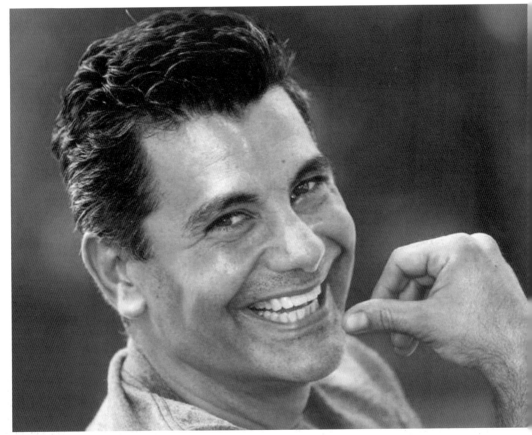

Steve Scionti: Actor and Playwright

A popular theater and movie actor, Scionti is best known for writing and starring in the critically acclaimed play *Hear What's in the Heart—A Shoemaker's Tale*, which is based on his experiences growing up in a Middletown Sicilian American family. Referring to the play, Scointi has said, "Family goes across all racial and ethnic lines. You don't have to be Italian to enjoy this show." To this statement, *New York Times* theater reviewer Alvin Klein added, "though Mr. Scionti makes you think you are." (Courtesy Steve Scionti.)

Katchen Coley: Environmental Activist

Coley was one of Middletown's most active environmentalists and a strong advocate for people with disabilities. She was the longest-serving board member of The Connection Inc., a human service agency she helped to found, and was instrumental in the successful effort to restore the Wadsworth Mansion and its grounds. In 2013, the Middletown Common Council named 50 acres of open space in the Maromas section of town the Katchen Coley Mountain Laurel Preserve. At the meeting, Mayor Dan Drew said Coley was "probably the greatest environmental activist I've ever known in my life." Coley passed away in 2013 at age 89. (Courtesy Phyllis and Katherine Coley.)

David Larson: Superintendent and Executive Director
After rising through the ranks in public education as a mathematics teacher, assistant high school principal, high school principal, and assistant superintendent of schools, David Larson was appointed superintendent of schools in Middletown in 1992. He served in that role for eight successful years, then took the position of executive director of the Connecticut Association of Public School Superintendents Association. In 2012, Middletown needed Larson's expertise again, and he filled in as interim superintendent until a permanent superintendent could be found.

Jennifer Alexander: Supporter of Kids Creative Play
Wesleyan graduate Jennifer Alexander, along with her husband, community activist Mark Masselli, has long called Middletown home. Alexander founded the Middletown Eye news blog, developed a community farmstand program that sold local fruits and vegetables in city neighborhoods, and created the Kidcity Children's Museum in 1998. Today, Kidcity, attracting over 100,000 visitors a year, provides a hands-on, interactive place where children ages one to eight can use their imagination to explore colorful play environments.

INDEX

Find more books like this at
www.legendarylocals.com

Discover more local and regional history books at
www.arcadiapublishing.com